PAUL KLEE

ENRIC JARDÍ

PAUL KLEE

EDICIONES POLÍGRAFA, S. A.

Reproduction rights: COSMOPRESS, Geneva
Translated by Jennifer Jackson and Kerstin Engström

I.S.B.N.: 84-343-0632-8
Dep. Legal: B. 37.960 - 1990 (Printed in Spain)

Color separation by Reprocolor Llovet, S. A., Barcelona
Printed and bound by La Polígrafa, S. A.
Parets del Vallès (Barcelona)

CONTENTS

Years of apprenticeship and years of travels 7

His art develops slowly 11

The Bauhaus 16

The brown tide and the last residence of the artist 21

Keys to an interpretation of Klee's work 26

Brief chronology 28

Bibliography 30

Illustrations 31

List of illustrations 126

Years of apprenticeship
and years of travels

I head these pages devoted to the first years of that highly exceptional artist Paul Klee with the titles of two philosophical novels written by J.W. Goethe about a famous character of fiction, Wilhelm Meister, with whom that author marked out a formative period, his *Lehrjahre* (the subject of the book that appeared in 1795), and another period of rewarding journeys, the *Wanderjahre* (a work published between 1821 and 1829).

I shall start by talking about the origins of the painter. He was born on December 18, 1879 in Münchenbuchsee, near Bern, the capital of Switzerland. His father, Hans Wilhelm Klee, of German nationality, was a music teacher at the Teacher Training College in the canton of Bern. His mother, Marie Ida, whose maiden name was Frick, was a singer. She was Swiss, although she had been born in Besançon.

Despite his birthplace, Paul Klee was in fact German. During the First World War he served with the Imperial Army, and although he settled permanently in Bern in 1934, he kept his German nationality until his death in mid-1940, thus dying not having obtained Swiss citizenship, for which he had applied at the beginning of that year. Hans Wilhelm Klee and Marie Ida Frick had two children, Mathilde and Paul. Their daughter, who was three years older than the future artist, in time became a language teacher.

In view of his father's profession and his mother's background, it need not surprise us that Klee was brought up in eminently musical surroundings. Indeed, the famous Parisian art dealer from the inter-war period, D.-H. Kahnweiler, the man who promoted Picasso, Braque and Juan Gris among other important figures in contemporary art, voiced the following opinion to one of his friends:

> Together with Henri Laurens, Paul Klee is one of the few painters with whom *one can really talk about music*. (Pierre Assouline, *L'homme de l'art D.-H. Kahnweiler 1884–1979*, Ballaud, Paris, 1988.)

In the artist's *Diaries* there is an abundance of well-informed comments on concerts or opera performances he attended, as well as of notes referring to his activities as a professional musician in Switzerland, as he played violin with considerable skill. It seems in fact that the fees he obtained from these were for many years the main source of income for his family, as some time passed before he was able to earn money from his painting, which the general public at first found hard to accept. And having

been born into a world of music, it could be said that Paul Klee never left it, since in 1906 he married Karoline ("Lily") Stumpf, a pianist from Munich, whose piano lessons also contributed to the family economy. Incidentally, one of his diary entries for the year 1905, in which the artist writes about his participation in a symphony concert, records his impression of another musician, the Catalan cellist Pau Casals:

One of the most wonderful musicians there have ever been (p. 133).

The reason I lay so much emphasis on Paul Klee's musical education and his skill as a violinist is because the paintings by this German artist, born near Bern, show a tendency towards nuances in tone very similar to that of music. The exquisitely sensitive lyrical poet Rainer Maria Rilke, who although he was from Prague nevertheless used German as his means of expression, wrote a letter to Wilhelm Hausenstein on February 21, 1921 thanking him for his monograph on Paul Klee, and explaining that around 1915 he had had "a number of engravings by the German painter in his room." He goes on to say:

Even if you hadn't told me he plays the violin, I would have guessed that on many occasions his drawings were transcriptions of music. ("Letter about Paul Klee," which figures as the first prologue to Klee's book, *Theory of Modern Art*.)

Parallel to his musical education, the artist attended classes at the "Gymnasium" of Bern, where he qualified in Humanities in the spring of 1898. It is important to emphasize this detail because Paul Klee always showed great interest in belles lettres, revealed not only by the fact that at about the time when he was completing his secondary education he began to keep a diary in which he wrote about his experiences and reflections, but also because during his life he wrote several theoretical works and gave some highly coherent talks about aesthetics in general. Furthermore, he was an indefatigable reader of limitless curiosity, and his diaries are full of notes about the books he read. On the other hand, he would often set down the titles of books in which he was interested, but rarely comment on them. His literary tastes were extremely wide, embracing both classical and contemporary authors, including Ovid, Shakespeare, Cervantes, Molière, Hebbel, Ibsen, Wilde, Zola, Tolstoy, Shaw, Chekov, and Gorky.

Klee's diary reveals that during the summer of 1898, the year in which he left school, he went on an excursion to the lake of Biel, taking with him colored pencils with which he made several landscape sketches. From this moment onwards, his vocation for painting began to grow stronger, so that he finally decided to take up Fine Arts at the university.

In October he obtained permission from his parents to move to Munich in order to attend Heinrich Knirr's studio, in which young men received the preparation necessary for admission into the prestigious Academy of the Bavarian capital. He also formed a musical quintet with Knirr himself.

Once admitted into the Academy, Klee was given classes by Franz von Stuck, who at that time was not only a very famous symbolist painter, but also a sculptor,

engraver, and architect. He was as many-sided as the renaissance artists, and had just joined the staff at the Academy, two years after founding the Sezession movement in Munich, in which the most avant-garde tendencies in contemporary art came together.

Not only did von Stuck enjoy great social esteem, but he was also a fine teacher. One of his pupils at the Academy, the Russian Wassily Kandinsky, who years later would form a brotherly relationship with Paul Klee and was to develop a tendency very different from that of the Bavarian maestro, wrote about his appreciation of Franz von Stuck's pedagogical aptitudes. By contrast, however, we do not know what young Klee thought about his teacher. In his diary he comments only that von Stuck had recommended him to begin his apprenticeship as a sculptor with professor Rümann, advice he was unable to follow due to the objections raised by the latter. On the other hand, we do know for sure that Klee studied the techniques of engraving under Ziegler.

After three years of studies in the Munich Academy, and having obtained his degree in Fine Arts, on October 9, 1901 Paul Klee and his fellow student, the sculptor Hermann Heller, set off on a journey to Italy. The adventure ended in May the following year, so that the two friends were able to experience a true *Wanderjahre*. Here Klee continued the tradition of so many German painters and writers in crossing the Alps on a journey of initiation to the South, where they were dazzled by the sun and so many classical works of art. Illustrious predecessors were Albrecht Dürer and Johann Wolfgang Goethe, and it is said that upon arriving in Italy the latter enthusiastically exclaimed: "Endlich ich bin geboren!" (At last I have been born!).

Klee and his friend Heller's itinerary was as follows: Bern, Milan, Genoa (where he had the wonderful experience of seeing the sea for the first time), Livorno, Pisa, Rome, Naples, Florence, always with the Swiss author Jakob Burckhardt's work *Der Cicerone* as their traveling companion (the subtitle of that most erudite and useful book is "Introduction to the Appreciation of Works of Art in Italy").

Needless to say his diary abounds in comments on the great works by the masters, which he contemplated with admiration and wonderment: Botticelli, Perugino, Raphael, Michelangelo, on sculptures by the artists of antiquity in the Vatican museum, on the Pompeian paintings of Naples, on the many opera performances he attended with music by Donizetti, Mascagni, Puccini and Wagner ("I maestri cantori"), and finally on his observations of the Italian way of talking and behaving. When he finally returned to Bern, everything he had seen had formed a kind of internal sediment, and he wrote:

So many changes deep inside me! I have seen at first hand the unfolding of a fragment of history. The Forum and the Vatican have spoken to me. Humanism wants to suffocate me; it is something more than a teacher's instrument of torture. I have to keep with it at least for a while!

However, classicism had no influence on the artist's production as an engraver begun the following year, because for the moment he was dissatisfied with his experiments as a painter. By virtue of their strongly distorted figures, in my opinion the etchings he produced from 1903 fall within the Gothic tradition.

Indeed, in the first work he produced with this graphic technique entitled *Jungfrau im baum* (Virgin in a Tree; Fig. 4), the naked body of the figure, placed in a very forced and unnatural position on the trunk and among the twining branches of a tree, is described through the use of angular strokes.

The same could be said about his second etching, with grotesque figures that Paul Klee defined as *Zwei Männer, einander in hohner Stellung vemutend begegnen sich* (Two Men Bowing to Each Other in the Belief that the Other is of Higher Rank).

In 1904 Klee produced two more engravings, one depicting a very stylized woman and a dog, and the other an actor hidden behind a mask, works which differed from those of the previous year since the artist now began to use dark backgrounds, due perhaps to a more pronounced baroque tendency.

Another episode in Paul Klee's personal *Wanderjahre* occurred at the beginning of June 1905, between Ascension Day and Pentecost, when he went to Paris with his Swiss friends Hans Bloesch and Louis Moilliet. His diary entries reflect the busy days he and his friends spent on their first visit to the captivating French capital: typical tourist days including activities such as visiting Montmartre, the Eiffel Tower, Versailles, and the Folies Bergère, but combined with such cultural attractions as visits to the Opera and the Comèdie Française, the Panthéon, the Luxembourg Contemporary Art Museum, and the Louvre. Hastily written notes give us some idea of the artist's preferences. He liked Leonardo, Tintoretto, Veronese, Watteau, Monet, Sisley, and Goya, of whom he writes:

> Beautifully blended shades of grey to black, interspersed with touches of flesh tones, like delicate roses.

We need not be surprised by Klee's preference for these painters who, despite their differences in style, origin, and period, have in common a sense of the fluidity of color that to a certain extent could be described as "musical."

In 1905, the year of his short but productive trip to Paris, he produced two further daringly innovative engravings with sarcastic overtones: *Held mit dem fügel* (Hero with Wing), a kind of warrior hero of ancient times with one wing and one arm, and *Greiser Phoenix* (Aged Phoenix), the mythological Phoenix which he represents as a plucked chicken.

In April 1906 Klee took advantage of his Easter holidays to visit Berlin, and as in Paris he visited her main monuments, and went to the theater and opera as well as museums: the Kaiser Friederich Museum, the Pergamon Museum, and the National Gallery, where he showed interest in nineteenth-century and contemporary painters such as Anselm Feuerbach, Hans von Marées, Adolf von Menzel, and Max Leibermann.

In June, ten of his etchings were shown at the Munich Sezession exhibition: the six aforementioned works and a further four pieces entitled *Feminine Grace, The Monarchist, The New Perseus*, and *Threatening Head*. At about the same time he had noted in his diary:

> Though I'm fairly satisfied with my etchings I can't go on like this. I'm not a specialist.

Towards the middle of 1906 he wrote:

I consider the engravings as "Opus 1," a completed "opus" belonging to the past. They seem to have constituted an episode in my life.

On September 15 of the same year that he traveled to Berlin and participated in the Munich Sezession, Paul Klee married Lily Stumpf in Bern, although the newly wed couple took up residence in the Schwabing district of the Bavarian capital, a neighborhood much favored by artists.

His work now became further diversified: he drew with a burin on blackened glass plates, thus achieving works of great expressive force, such as the magnificent portrait of his father, and painted watercolors of the outskirts of Munich and Bern. At the same time he tried to have his work published in illustrated magazines and by art publishers, but with little success.

In November 1907 Lily Stumpf gave birth to a son, whom the artist and his wife named Felix. He was to be their only child and would cause them great worry at the age of two, when he fell gravely ill. To their relief, however, he eventually managed to recover.

It was at this time that Klee sent three engravings to the Munich Sezession, which was held from May 15 until the end of October 1908, and another six works to the Berlin Sezession which took place in December that same year.

His art develops slowly

So far the graphic aspects of Paul Klee's work had been shown in the aforementioned group exhibitions. The opportunity to hold a major one-man exhibition arrived in 1909. For an event of such magnitude in his professional career, the artist chose his birthplace or, to be more exact, the town where he had spent his childhood, Bern.

The exhibition was held in the Kunstmuseum, the art museum of the capital of the Helvetian Confederation. It was opened in August, and on closing traveled to the Kunsthaus in Zurich (October) then to the private Zum Gallery in Winterthur (November 1910), finally ending its tour in the Kunsthalle in Basel. The show consisted of fifty-six works, mainly watercolors, watercolored or pen and ink drawings, and paintings on glass.

His diary notes the curious letter sent to him by the director of the Zum Gallery, informing him that:

most of the visitors criticize your works and several well-known and respected people have requested that they be removed.

11

While asking the painter for specific instructions in the matter, he suggested that perhaps it would be expedient to have some written explanations as to the meaning of the pieces on show, which could be given to the public. Paul Klee reacted with a certain degree of irony, saying that the artist who needs to supply explanatory notes and comments on his work shows little faith in it, on the other hand adding that many artists had fallen victim to the incomprehension of the public at the beginning of their careers, among them the great Berlin painter Ferdinand Hodler. And as if this were not enough for the priggish director of the Winterthur showrooms, Klee sent him a copy of the review of his last exhibition in Zurich which had appeared in one of that city's publications. It was of course certain that Paul Klee's art could not please a public with conservative tastes, as it was becoming less and less academic.

His interest began to grow in the instinctive forms of plastic expression. A note in his diary from the beginning of 1912 says that artistic principles of great originality can be found both in the work of primitive peoples, on show in ethnological museums, and in children's drawings.

Given such sensitivity, Klee found a rapport with painters and writers who, like him, coincided in their rejection of academicism. In the summer of 1911, after having thirty of his drawings shown on the premises of the forward-looking Munich gallery owner Tannhauser, he joined a set of painters, poets, and critics in the Bavarian capital who were trying to form a group of innovative artists who would present themselves under the name of Sema, but the project petered out after the exhibition held in April 1912 in the Tannhauser showrooms.

Shortly afterwards, however, he established a much more fruitful contact with Wassily Kandinsky, the Moscovite who at the age of thirty gave up his profession as a lawyer to study painting with von Stuck in the Munich Academy. Klee did not meet the Russian at the Munich School of Fine Arts, however. The friendship was initiated by a mutual friend, Louis Moilliet, the painter from Bern with whom Klee had visited in Paris.

Although Kandinsky lived in the Bavarian capital, indeed in the same street as Klee, the latter was very shy so it was Moilliet who introduced the artists to each other's work. On seeing Kandinsky's pieces, Klee qualified them as ''strange paintings.'' When the two artists finally met, Klee was enchanted by the painter from Moscow, noting in his diary:

On meeting him personally I came to feel a deep trust in him. He is somebody, and has an exceptionally beautiful and lucid mind,

and adding that they decided to continue seeing each other. During the winter of 1911 Klee decided to join his ''Der Blaue Reiter'' (The Blue Horseman) group, whose curious name is taken from the title of a painting by the Russian.

This group, born from the splitting of the ''Neue Kunstlervereinigung Munchen'' (New Association of Artists of Munich), founded by Kandinsky in 1909, held its first show on September 18, 1911 in the Tannhauser Gallery which, apart from works by the promoter, exhibited paintings by the Germans Franz Marc and Auguste Macke, the two Russians David and Vladimir Burliuk, the Frenchman Robert Delaunay and

other less well known artists. Surprisingly enough, in that group show by "Der Blaue Reiter" works by the "Douanier" Rousseau and some painting experiments by the composer Arnold Schönberg were also on show. The latter in fact had published his revolutionary *Treatise on Harmony* that same year.

In 1912 the artists of "Der Blaue Reiter" published an almanac containing essays on theory by Burliuk, Macke, Schönberg, Marc and, of course, Kandinsky, specifically a number of the writings he was to include in his book *Über das Geistige in der Kunst insbesondere in der Malerei* (Of Spiritual Harmony in Art and Especially in Painting), published the same year.

Although Paul Klee had joined the group led by Kandinsky, he did not participate in their first exhibition. On the other hand, he contributed sixteen pieces to the second of its shows, held in February in Hans Goltz's gallery in Munich. This audacious dealer, who exhibited works by Picasso, Derain, and Braque, organized another group showing of contemporary artists, not all of whom belonged to "Der Blaue Reiter," but among whom we find Paul Klee (this show later traveled to Berlin).

From April 2 to 18, 1912, taking advantage of the Easter holidays, the artist made another trip to Paris and, as he had done in 1905, spent most of his time visiting museums and modern art galleries. He noted in his diary that he had seen works by Matisse in the Berheim-Jeune Showrooms, paintings by Picasso and Braque in the Wilhelm Uhde Gallery, and pieces by Picasso, Derain, and Vlaminck in the Kahnweiler Gallery. He mentions that he had met the cubist painter Henry le Fauconnier, who in 1911 had exhibited in Munich with the aforementioned group that Kandinsky had inspired prior to founding "Der Blaue Reiter."

During his visit Paul Klee also met Robert Delaunay, the only French artist invited to participate in the first "Der Blaue Reiter" exhibition held the previous year, who had graduated from Impressionism to Cubism through Cézanne and later evolved a very personal concept of rhythmic abstraction based on combinations of primary colors.

Proof of Klee's sincere admiration for Delaunay is to be found in his translation of the latter's *Sur la Lumière* which, under the title of *Uber das Licht*, appeared in the January 1913 issue of the fortnightly Berlin journal of art and culture *Der Sturm* (The Storm), a daring publication founded ten years before by Herward Walden, in which Klee also collaborated in December 1913 with a pen and ink drawing bearing the inscription *Kriegerischer Stamm* (Warrior Tribe). The composition is tilted and represents a shapeless mass of warriors (to judge by the vertical lines suggesting lances or pikes), a deliberately aggressive, brutal and primitive work. It is no coincidence that the painter Franz Marc, one of the members of "Der Blaue Reiter" with whom Klee soon became friends, had claimed for the group the name of "the Savages of Germany" through the pages of the journal published by them in January 1912. We should keep in mind also that the name *fauves* (wild beasts) had been coined by a critic who applied it to the group of avant-garde painters, Matisse, Derain, Marquet, and Vlaminck, who exhibited in the Paris Salon d'Automne, and that Klee himself in the year of his graphic contribution to *Der Sturm* had expressed his appreciation of the art of primitive peoples and children's drawings.

Walden also had a gallery in the capital of the German empire, where since its beginnings he had shown the early work of the most avant-garde artists of Germany, Austria, France, Italy, and Russia. Here, therefore, we find the explanation of why Paul Klee's works figured in collective exhibitions that opened in the Berlin showrooms of *Der Sturm* in 1912 (April–May), 1913 (March, May, September, and December; 1st German Autumn Show), 1914 (April), 1915 (June–July), 1916 (March, July, and August), 1917 (March–April and December), 1919 (January), 1920 (September) and 1921 (July–August).

But I am jumping ahead in the chronological order I imposed on the telling of this story, so I shall make amends by saying that in April 1914 Klee made a thirteen-day visit to Tunis which was to have a great impact on his art. The journey was made with two friends of his, the Swiss Louis Moilliet and the German August Macke, whom he had met in "Der Blaue Reiter." A pharmacist from Bern called Bornand covered Klee's traveling expenses, while the three artists' stay was financed by Jägi, a doctor from Bern who lived in the residential area of Saint Germain in the Tunisian capital. On this trip Klee was enraptured by the light, and he wrote in his diary:

> The color has seized hold of me. I do not need to take it. It has taken me forever, I know. This is the meaning of this happy hour; color and I are as one. I am a painter.

After his exclusive devotion to graphics, he proved indeed to be a true painter in his watercolors inspired in the city itself, in its European quarter, in Hammamet and Kairuan, and in which he attempted to create a pictorial architecture on the basis of a synthesis of urban architectures.

On his return journey to Germany he passed through Naples, Rome, Florence, and Milan, and was once more at home with his family on April 25. Shortly afterwards, he and some of his artist friends who lived in the Bavarian capital founded the "Neue Munchener Sezession" (New Secession of Munich) and contributed eight works to the group's show that opened on May 30.

On June 29, 1914 the Sarajevo pistol shot which assassinated the heir to the Austro-Hungarian Empire unleashed the terrible chain of slaughter which was to be the First World War. Although the war did not actually break out until August 3, it naturally caused great upheavals in the lives of the subjects of what would soon be called the Central Empires of the Belgian King, of the Tzar of Russia, and of the states that allied themselves against Austria, Hungary, and Germany, that is, France and the United Kingdom.

Paul Klee was devastated to hear of the death of his friend Franz Marc at the Verdun front, where nearly half a million soldiers on both sides lost their lives. Marc was killed on March 4, 1916. On the eleventh of that month Klee was called up and sent to the Landshut Barracks for infantry recruits, and shortly afterwards transferred to the Reserve Air Force in Schlessheim, also in Bavaria, without any request having been made on his part. Finally, in January 1917 he was sent to the School of Pilots in Gersthofen and assigned to the pay office.

It cannot therefore be said that Klee's life was seriously affected by the war. Indeed, he even had the opportunity to make a short visit to Switzerland, the neutral country that gave shelter to refugees from warring countries who later became famous in the fields of art and music: among others Romain Rolland, James Joyce, Tristan Tzara, and Stravinsky. It was in Bern in 1916 that the artist met someone who years later was to be his dealer, namely D.-H. Kahnweiler, born in Mannheim, whose Paris gallery Klee visited almost furtively in 1912 (Kahnweiler had to leave France on account of his being a German subject).

The Armistice of November 11, 1918 marked the end to hostilities, and Klee was demobilized and able to return to family life in Munich. However, the political and social situation in Bavaria was in a state of turmoil. King Ludwig III was deposed at the same time that the German Emperor Wilhelm II fled to Holland. At the same time revolution broke out in Berlin and other important cities, reflecting what the Bolsheviks had achieved in the Russian Empire in October the previous year. The ancient Kingdom of Bavaria now became a Socialist Republic presided over by the independent social democrat Kurt Eisner. When he was assassinated in February 1919, a Soviet Republic was set up and governed by a "Central Council of Workers, Peasants, and Soldiers," led by the writer Ernst Toller. At that time, when Klee and his family had moved into an apartment in the small baroque Palace of Suresnes in Munich, he was appointed member of the Advisory Council of Artists of the Communist Government, an entity that on April 22 reached the extreme of proposing such radical measures as the confiscation of all art collections in the city and their subsequent sale abroad in order to raise funds for social ends.

Around the middle of May the Revolution was suppressed by Gustav Noske, Minister of the Interior of the German Republic, who sent in units of the paramilitary "Freikorps." The artist, who dared not leave his home for several days for fear of government repression (unaware, incidentally, that Toller was in hiding in the next-door apartment), decided to move temporarily to Bern.

Some people who have commented on the work of the German artist, especially O.K. Werckmeister (in his work *From Revolution to Exile*, included in the monumental catalogue for the Klee exhibition held in New York's Museum of Modern Art in 1987), attach singular importance to the artist's pencil drawing entitled *Versunkenheit* (Abstraction), dated 1919 and currently in the Norton Simon Museum of Pasadena, California. It depicts a man without ears or lips and with his eyes tightly shut, as if wishing to convey a determination to concentrate, to isolate himself from the outside world. In the opinion of this historian, the work in question may be a self-portrait or, more exactly, a self-caricature that betrays the mood of the painter sunk in a process of interiorization, his hopes raised at the outbreak of the Bavarian revolution now shattered by the atrocities committed, and he himself sickened by the brutality of Noske's repressive methods.

It was in that same tragic year of 1919 that Paul Klee attempted to secure a teaching post at the Academy of Art in Düsseldorf, but his efforts were in vain, despite the recommendations of his painter friends Willi Baumeister and Oskar Schlemmer. Instead, he signed a three-year contract with the dealer Hans Goltz, whose Neue Kunst Gallery enjoyed a situation of privilege in Munich. A further positive event in Klee's

life in 1919 was the appearance of a book illustrated by him which was brought out by the Munich publisher Muller. It is entitled *Postdamer Platz oder die Nächte des Neuen Mesias*, with the subtitle *Ekstatische Visionen*, that is, Postdam Square or the Nights of the New Messiah-Ecstatic Visions. This biting social satire is the story of an innocent provincial who tries to redeem the prostitutes who abound in a central square of the German capital.

Paul Klee's illustrations consist of six pen and ink drawings which have little connection with reality, although their jagged, angular lines do suggest the dynamic force of the big city. The book has a prologue by Eckart von Sydow, the historian and art critic from Leipzig, to whom it seems we owe the idea of this publishing project which came to fruition in 1919, although Paul Klee had been commissioned to do those daring illustrations when he was still enlisted.

The following year the German artist born in Bern was to begin collaborating in a teaching experiment that would have great impact on the culture of the plastic arts of this century: the Bauhaus.

The Bauhaus

After the war, in 1919 the Weimar School of Arts and Crafts, which in 1902 the Grand Duke of Saxony-Weimar had entrusted to Henri van der Velde, an outstanding figure in the *fin-de-siècle* applied arts of the Modern Movement in Belgium, was restructured and renamed the "Staatliches Bauhaus." The director of the reopened school was the Belgian architect Walter Gropius, who shortly before the outbreak of war had stood out among the group of builders calling themselves the "Werkbund." Gropius did not recognize any distinction between the concepts of "artist" and "craftsman," refusing to give credit to the professionalism of artists. "The artist," he would say, "is only a craftsman of a higher order."

In the initial manifesto of the Weimar "Staatliches Bauhaus" (House of Construction), published in April 1919, Gropius announced his plan to create a new building of the future where architecture, sculpture, and painting could be joined as one entity: a building constructed by millions of craftsmen, symbolizing a new faith that would dominate the future.

The first Directors' Council of this ambitious educational entity was formed by the sculptor Gerhard Marks and the painters Lyonel Feininger and Johannes Itten, to be joined a short time later by Gropius' colleague in the "Werkbund," the architect Adolf Meyer. Itten, who from the first assumed responsibility for the pedagogical orientation of the Bauhaus, and who attached greater importance to the media of expression than to the subject matter of works, was a native of Bern and, although he had begun as a teacher of natural sciences, had benefited from music lessons

imparted by Hans Klee. Through him he met his son, Paul, from whom he bought some drawings. It is very likely that Johannes Itten could have been a decisive influence in the fact that in October 1920 the directors of the progressive school in Weimar invited Paul Klee to join its teaching staff. In May of that same year, in the Munich Neue Kunst Gallery owned by Hans Goltz, 363 of Klee's works had been exhibited: oils, drawings, watercolors, but mostly compositions using mixed media such as pen and ink drawings, washes and colored pencil, and touches of gouache, abstract in theme or with vaguely anthropomorphic references, sometimes with autographic annotations by the artist, generally at the foot of the work, which could be said to form part of it and which indicate the title chosen by the painter. These titles are often enigmatic, such as *Solo by Fatal Bassoon, Astral Automatons, An Angel Serves a Small Breakfast* (Fig. 22), or *Once Emerged from the Gray of Night*... (Fig. 14). These annotations, made in careful handwriting, are accompanied by Klee's signature and a number corresponding to the general cataloguing of the artist's works which he had begun in 1911. In the one-man exhibition at the Neue Kunst Gallery, Paul Klee revealed the unmistakably ineffable, delicate style that was to characterize his work for approximately a decade.

The year of his major Munich exhibition and of his appointment as teacher in the Bauhaus was also the year that saw the publication by the Munich editor Kurt Wolff of Voltaire's classic *Candide or the Best of all Possible Worlds* in a German version that includes twenty-six bold pen and ink drawings, illustrations which Klee had done in 1911 and shown to his artist friends — Kandinsky was particularly enthusiastic about them — but which he had never managed to sell to any of the several publishers with whom he negotiated.

In January 1921 Paul Klee began his teaching activities at the Bauhaus in Weimar, where he settled with his family in September. Initially Klee was responsible for the book-binding workshop and gave classes on "Contributions to the Theory of Form" in the preparatory course run by the Swiss Itten. Later he taught the techniques of painting on glass and fabrics. He explained to his students that the mission of a painter consists in elaborating an expressive world parallel to that perceived by the eye, although both are interrelated since they are united in the Cosmos. Above all, in fulfilling his mission the artist must always act with absolute purity. Frequently Klee would give his classes in front of the blackboard, drawing with both hands (it is said that he played violin with his right but painted with his left), explaining how to create the third dimension starting from a flat surface and showing how it was possible to graduate color without recourse to material density.

Paul Klee combined his teaching activities in Weimar with his painting, which he was able to carry out in two studios given over to him in the Bauhaus building itself, and it was during his first year as a teacher at that innovative school that the Munich publisher Kurt Wolff brought out the first study on his art, based specifically on his experiences in Tunisia. It was written by Wilhelm Hausenstein and entitled *Kairuan oder eine Geschichte vom Maler Klee und von der Kunst dieses Zeitalters* (Kairuan or a Tale of the Painter Klee and the Art of this Century). This is in fact the work to which I referred earlier when quoting the poet Rilke's opinion of Klee's *oeuvre*.

In 1922 the two friends Klee and Kandinsky were reunited when the latter joined the staff of the Bauhaus, giving classes both in the preparatory course run by Johannes Itten and in the mural painting studio. The following year Klee held a major one-man exhibition in the Kronprinzenpalais in Berlin, and participated in the first Bauhaus exhibition and festival, held in Weimar from August 15 to September 30. This event was advertised with a three-colored lithograph by Paul Klee, a strange but beautiful geometric composition which seems to evoke a construction either reminiscent of or symbolizing the school itself (the House of Construction). For the same festival he also designed a daringly avant-garde visitor's card. Furthermore, to celebrate this event a publication appeared including an essay by Klee entitled *Wege des Naturstudiums* (Approaches to the Study of Nature).

In 1924 Paul Klee's work was first exhibited on the other side of the Atlantic. This took place in New York from January 7 to February 7 in a gallery in West 57th street, thanks to the intervention of Katherine Dreier, promoter of modern art and the driving force behind the Société Anonyme. On January 26 of the same year, and on the university campus of Jena, Klee addressed the "Kunstverein" society with a lecture entitled "Uber die Moderne Kunst" (About Modern Art), the text of which was not published until 1945 in Bern.

On resuming his teaching activities, after productive summer holidays spent in Sicily (he had spent the previous year's holiday near the North Sea), Klee encountered an atmosphere of considerable unrest. The politicians with more conservative tendencies, who had just gained control of the Municipal Chamber upon which the Bauhaus depended, were clearly ill-disposed towards the school, and as a result of this on December 26 the activities of the Weimar "House of Construction" came to a complete halt. Fortunately, however, the by now prestigious institution found shelter in the Municipality of Dessau, and it was here that Walter Gropius planned his audacious buildings destined to be the school itself and staff residences. Furthermore, in homage to the temporarily closed entity, in 1925 Gropius and Lazlo Moholy-Nagy published through the Munich House of Langen a collection of books by members of the Bauhaus, the second of which was a work by Klee, *Pädagogisches Skizzen-Buch* (Pedagogical Sketchbook).

The year 1925 was an important landmark in the diffusion of Klee's work: his exclusive contract having expired with the Golz Gallery, where he held a farewell exhibition of all his output between 1920 and 1925; he next entered into a new commitment with the equally daring art promoter Alfred Flechtheim. Moreover, 1925 saw new advances in the spread of Klee's fame as a painter abroad. Firstly, on March 31 an exhibition opened in the Daniel Gallery in New York, with works by Klee, Lyonel Feininger, Wassily Kandinsky, and another Russian, Alexei von Jawlensky, who had been a member of the group Kandinsky had founded prior to "Der Blaue Reiter." These European artists were presented in America by Galka Scheyer under the title of "Die Blauen Vier Group" (The Blue Four). Secondly, it was in 1925 that Klee's work was first shown in Paris, that metropolitan melting-pot of all the arts and scene of the most innovative experiments in the plastic arts between the wars. From October 21 until November 14 thirty-nine of his watercolors were hung in the Galerie Vavin-Raspall

in the very heart of Montparnasse, with its bustling swarm of avant-garde artists and critics.

Klee's work was very well received by the more refined spirits. The dealer Kahnweiler, who despite his German origins was a man of French tastes, showed absolutely no enthusiasm for the artistic output from beyond the Rhine. In a letter to his friend Leibowitz, exhumed by Assouline in the aforementioned book, he attacks with relish the much appreciated painters in Germany such as Franz Marc, August Macke, or Kandinsky, whom he qualifies as an "oriental decorator" and expresses his surprise at the fact that he should have written an essay on *The Spiritual in Art*, when as far as he is concerned Kandinsky is the least spiritual of painters. Indeed his disapproval of the leading figures of "Der Blaue Reiter" was such that he dismissed them outright as having merely produced a decorative version of Fauvism. The only German in the group who emerges unscathed from this Mannheim-born Parisian gallery owner's diatribe is none other than Paul Klee, described textually as "the only outstanding one amongst them." Even so, such support by Kahnweiler need not surprise us, if we take into account that it was given when the tendency known as *Art Vivant* was at its height.

His exhibition in the Vavin-Raspail Gallery was accompanied by a catalogue bearing a laudatory text by Louis Aragon and a poem by Paul Éluard. These French men of letters enthusiastically championed the art of Paul Klee, and due very probably to their direct intervention two works by the German figured in the sensational first exhibition of what was to be called "Surrealist Painting," which the wise promoter Pierre Loeb offered at his Galerie Pierre between November 14 and 15 of the same year. Indeed, the Paris Surrealists were so fascinated by the disturbing message contained in Klee's art that they invited him to contribute a drawing to issue no. 3 of their journal *La Révolution Surréaliste* (1925).

In December 1926 the new premises of the Bauhaus, designed by Gropius, were opened in Dessau. In the month of July the Klee family occupied their half of a two-family house, also designed by that audacious architect. Wassily Kandinsky and his wife Nina lived in the adjoining house, so that the friendship between the two artists became even stronger, fortified by their almost daily contact. When the Russian turned sixty, many of his friends, mainly the Bauhaus teachers, organized an exhibition in his honor in the Arnold Gallery in Dresden and published a catalogue containing several texts, one of which was by Paul Klee. He also contributed another text to the homage that was paid the following year to the great German painter Emil Nolde, founder of the "Neue Sezession" of Berlin and associated with the "Der Blaue Reiter" movement, on the occasion of his sixtieth birthday. This text appeared in a work published by the Neue Kunst Fides Gallery in the city of Dresden. Also in 1927 Klee held a major exhibition of oil and watercolor paintings in the Düsseldorf gallery owned by his dealer Alfred Flechtheim.

In March 1928 this promoter organized in the same gallery another exhibition of Klee's work — a total of fifty-six paintings — with a catalogue featuring a text by the French Surrealist René Crevel, and towards the end of the year the art of Paul Klee reached Belgium in the form of a show at the Centaure Gallery, Brussels. In a way the year 1928 is a milestone in the German painter's career, as besides the two

aforementioned exhibitions, in February of the same year an article of his of great substance, *Exakte Versuche im Bereich der Kunst* (Exact Investigations in the Realm of Art), appeared in the journal *Zeitschrift für Gestaltung*, published by the Bauhaus.

That same year a crisis occurred in the progressive school of Dessau: Walter Gropius resigned as director. He was succeeded by the Austrian architect Herbert Bayer, an outstanding student of the institution (later the post was occupied in turn by the Hungarian architects Marcel Breuer and Lazlo Moholy-Nagy, and finally in 1930 by the celebrated German architect Ludwig Mies van der Rohe).

The year 1928 had further significance in the biography of Paul Klee, as in December he set out on a journey to Egypt, having spent his summer holidays in Brittany (in 1927 he had been in the south of France and Corsica, and in 1926 he had traveled around southern Italy). Seeing the ruins of ancient civilizations in the country of the Nile, and especially his contact with the Moslem world, caused a great impact on Klee's artistic sensitivity, comparable only to that produced during his stay in Tunisia. Comments on the art of Paul Klee that detect a possible influence which Islamic calligraphy may have had on his characteristic sense of drawing are in my opinion not totally mistaken.

Around the middle of January 1929 he returned from Egypt via Italy. From February 1 to 15 forty of his works are shown in the Parisian gallery of Georges Bernheim-Jeune, with a preface by René Crevel in the catalogue. When the exhibition in the French capital closed, the Neue Kunst Fides gallery in Dresden exhibited 105 of his pieces between February and March. In the summer of 1929 Paul Klee and his wife accompanied by the Kandinskys traveled to the French Basque Country, where on Hendaye beach Lily Klee took a curious photograph of the German and the Russian grasping each other's outstretched hands in imitation of the gesture by the pre-romantic German authors Schiller and Goethe. From October 20 to November 15 another exhibition of Klee's work was held in Alfred Flechtheim's Berlin gallery. Coinciding approximately with Klee's exhibition in Paris, the publishing house Cahiers d'Art brought out a book on the artist by the German Will Grohmann. This was in fact the first monographic study of his work, as the book by Hausennstein which appeared in Munich in 1921 was based only on the painter's Tunisian experiences. I should add that the book by Grohmann (which was not published in its original version until 1954 in Stuttgart) was enriched in this 1929 French version with texts by Louis Aragon, René Crevel, Paul Éluard, Jean Lurçat, Philippe Soupault, Tristan Tzara, and Roger Vitrac. In other words, it was presented to the French public with the guarantee of the most esteemed literary figures in avant-garde circles.

Between February 15 and March 20, 1930 an anthological exhibition on Paul Klee was held in the Alfred Flechtheim Gallery in Düsseldorf. It showed work executed over the last twenty-five years and included watercolors, engravings, and drawings, the latter (fifty in total) being the object also of a special show held in the Nationalgalerie in Berlin in the spring of the same year. Also in 1930, and between March 13 and April 2, sixty of his pieces were exhibited in the magnificent Museum of Modern Art in New York, directed by Alfred H. Barr jr., who himself wrote the text for the catalogue. It could therefore be said that after the memorable New York exhibition organized by the Société Anonyme in 1924, Paul Klee's painting began to

consolidate an increasingly prominent position in North American art circles. After this exhibition in the city of skyscrapers, between May 1 and 15 of the same year another of his one-man shows was held in the Braxton Gallery in Hollywood, along with a joint exhibition with other modern German artists held at about the same time in Cambridge, Massachusetts. This exhibition, which lasted from December of that year until January of the following year, was under the auspices of the Harvard Society for Contemporary Art, a university entity which also patronized an exhibition of Bauhaus artists to which Klee contributed fifteen pieces.

The art of Paul Klee had been undergoing changes since around the previous year. Without completely abandoning those compositions of subtly shaded colors with their incidence of abstract writing or suggestions of childish graffiti or the art forms of primitive civilizations, which characterize his output from the early twenties, now he preferred painting combinations of geometric forms and sequences of color without the remotest reference to reality. Later on, in 1931 and 1932, he would paint using the *pointilliste* technique of small dots to obtain a delicate tonal polyphony.

At the beginning of the thirties Paul Klee decided to leave the Bauhaus, as he did not feel at ease under the successive changes of management or the increasingly virulent social and political debates and controversies that took place in the school. This led to his establishing contact with the Art Academy in Düsseldorf with a view to joining the teaching staff there the following academic year. Indeed, he duly took up his post as a teacher on April 1, 1931, although for the time being he did not abandon his residence in Dessau. From March 7 to April 5 of that year he exhibited in the Kestner-Gesellschaft in Hannover; from June 14 to July 6 in the Kunstverein für die Rheinland und Westfalen in Düsseldorf (with a presentation text by Will Grohmann); and from November 5 to December 10 in the Alfred Flechtheim Gallery in Berlin. In addition he participated in several collective exhibitions by German artists, in particular one by "Die Blauen Vier" in New York, Buffalo, and San Francisco.

The fast-moving chain of political upheavals that Germany was undergoing at that time was to produce major changes in the life of Paul Klee, to which I shall now refer by beginning a new chapter.

The brown tide
and the last residence of the artist

The Austrian Adolf Hitler, former volunteer soldier of the Bavarian army, who in 1921 had taken over the leadership of the Nationalsozialistische Deutsche Arbeiterpartei (German National Socialist Workers' Party), better known as the NSDAP or "Nazi" party, and who two years earlier had failed in an attempted coup d'etat in Munich, was a growing figure in the politics of a country that was going through a serious

economic recession as a result both of the crash of the New York Stock Market in 1929 and of demands on the part of the victors for indemnity for war damages. Resentment against the severe conditions imposed by the treaty of Versailles and the threat of rising unemployment formed a spawning ground for the party led by Hitler, not only strongly nationalistic but also rabidly anti-semitic, and in the eyes of the bourgeoisie the greatest possible defense against the subversive doctrines of communism.

After some election defeats, in 1930 the Nazi Party obtained 107 seats in the Reichstag or Legislative Chamber of the Republic, and in 1932 it won an even greater number of seats, which secured the absolute majority. The NSDAP had also swept the board in the local elections: in 1931 it controlled the Municipal Council of Dessau and a decision was made to authorize no further subsidies to the Bauhaus. Later, in October 1932 it was decided to close down the progressive teaching institution that Mies van der Rohe had attempted to establish in Berlin that same year.

In January 1933 the President of the Republic, Paul von Hindenburg, appointed Hitler Chancellor of the Reich (a post equivalent to that of Prime Minister), and shortly afterwards the Austrian awarded himself full powers. The National Socialists, with their brown-shirted storm troopers, became the undisputed masters of the country.

Although Paul Klee had not signed the manifesto of artists, writers, and intellectuals against Nazism, since he naively believed that the party in power would respect the ideological pluralism of German society, he had the extremely disagreeable surprise one day of having his house searched in his absence by Nazi agents, who confiscated many papers, including the artist's letters to his wife. As a result of this Klee decided to take up residence in Düsseldorf. This occurred towards the end of March. In April the new German government finally closed the Bauhaus in Berlin (in 1937 one of its former directors, Moholy-Nagy, founded the "New Bauhaus" in Chicago). At the beginning of May, Paul Klee was suspended from his post as teacher in the Academy in Düsseldorf and at the beginning of January the following year he was officially dismissed.

The National Socialist newspaper in Dortmund, *Die Rote Erde,* in its first February issue in 1933, which appeared two days after Hitler took power, published a vicious article entitled *Kunst-Stumpf in Westdeutschland* (The Swamp of West German Art), which denounced the fact that Paul Klee was teaching in the Academy of Art in Düsseldorf, describing him as "a notorious Jew from Galitzia (Poland), although he himself claims to belong on his mother's side to an Arab race from the North of Africa." This is a doubly false statement since neither did the painter's father come from that Eastern European region, formerly under the Austro-Hungarian Empire, where the Hebrew population abounded, nor did his name originate in North Africa (the latter hypothesis, that has absolutely no foundation, had been put forward by Haustein in his essay on the artist's productive stay in Tunisia in 1914).

In October of that ill-fated year of 1933 Klee made a trip to the south of France (having traveled in northern Italy the year before). On his return journey he made

a stop in Paris to negotiate an exclusive contract with D.-H. Kahnweiler, who at that time was running the Galerie Simon, since his usual agent, Alfred Flechtheim, had been forced to cease his activities as gallery owner because of his Jewish origins. He took advantage of his stay in the French capital to visit Pablo Picasso, thus having the opportunity to meet in person an artist he so greatly admired. He had seen some of the works by the painter from Málaga before the war in the Munich Tannhauser Gallery, in the Uhde and Kahnweiler galleries during his previous visit to Paris, and also in a large exhibition in Zurich in the autumn of 1932, when he went to the north of Italy on holiday.

Due to the oppressive political climate that prevailed in Germany, and to his precarious existence in Düsseldorf, Paul Klee moved to Switzerland in December 1933, settling provisionally in his family home in Bern with his wife and son. By the spring of 1934 he had managed to acquire a home of his own in Elfanau, a residential area of the Swiss capital, although he had to live somewhat modestly.

In January of 1934 Paul Klee held his first individual exhibition in the Mayor Gallery in London, and from June 12 to 15 another show was held in the Galerie Simon, Paris. Kahnweiler had visited him earlier at his home in Bern and had tried to persuade him to leave Switzerland and take up residence in Paris, where contemporary art was flourishing and where he could attain greater fame. However, Klee did not seem to be very enthusiastic about presenting himself as a modern painter, according to the opinion of the gallery owner as expressed in the aforementioned book by Assouline, where he relates the surprising impression made on Kahnweiler when he saw the artist, characteristically courteous and reserved (in fact he was extremely shy) at work amidst the furniture of the living room in his tiny Elfenau apartment. The dealer recalls that Klee offered him a violin concert, accompanied by his wife at the piano, and comments on his astonishment at the fact that an artist as accomplished in the avant-garde plastic arts should prefer the music of Haydn to that of Schönberg, despite having known the latter during his time in Munich.

In the same year as his London and Paris exhibitions, the painter suffered another humiliation at the hands of the national socialists, who by now completely dominated his homeland: a monograph by Grohmann on drawings by Klee during the period between 1921 and 1930 was confiscated (it was not to appear again until 1944, in an English translation in New York). The previous year his works had been removed from all German museums in compliance with a "Civil Administration Reform Law" which had been decreed by Joseph Goebbels, then Minister of General Education and Culture in Prussia.

In 1935 he once again exhibited at the Mayor Gallery in London, and 273 of his works were shown in the Kunsthalle in Bern from February 23 to March 24, an exhibition which to an extent was repeated in the Kunsthalle in Basel, though with a smaller number of pieces (191), from October 27 to November 24. That same year he exhibited on three occasions in the U.S.A.: in New York and in the Contemporary Art Circle, firstly in oils (from March 2 to 15) and then in watercolors (from March 18 to 30), and also in Oakland, California in October.

Towards the end of 1935 Paul Klee fell ill, apparently suffering from measles. The following year, however, an exact and sadly fatal diagnosis was made: he was suffering from scleroderma, an incurable disease which to the layman could be described as the progressive drying up of body fluids that manifests itself in a variety of ways. In the case of the artist his esophagus gradually lost elasticity, reaching a point where he was unable to swallow solid food and had to rely on liquids. D.-H. Kahnweiler tells that he would often lunch with Paul Klee and observed the difficulty the artist had in swallowing his food, so much so that he would unobtrusively drink between each mouthful. To avoid a distressing spectacle, Klee eventually decided to take his meals alone. He gave up smoking and playing the violin, lost weight, and his skin tightened, slowly changing his appearance.

Nonetheless, the artist's state of health would vary, and he felt somewhat better after his stays in three sanatoriums in the canton of Valais. Indeed, Klee was a man of great will power: he stopped painting standing up, as was his usual practice, and would paint from a chair, and according to his son Felix he produced thirty-six works in 1936, during the most critical period of his illness. That year his exhibition list shows only one exhibition, the one comprising fifty works which was held in the Wadsworth Athenaeum in Hartford, Connecticut, from January 21 to February 11.

Paul Klee's work was by now becoming more widely known in the United States, thanks above all to German art dealers who had fled their country for political or racial reasons. Either independently or in collaboration with American colleagues, they arranged exhibitions of his works, so that in 1937 Klee had three exhibitions: in the East River Gallery in New York, in the Putzel Gallery in Los Angeles, and in the museum of San Francisco.

That same year, however, Paul Klee was to suffer yet another insult on the part of those of his countrymen who unfortunately had acquired absolute and despotic power. Within the framework of the corporate structure they had imposed upon German society, the National Socialists set up a Reichskulturkammer (State Chamber of Culture) with a subsection or Chamber of Figurative Art which grouped together all painters and sculptors under the protection of a "House of German Art," whose headquarters were in Munich. The foundation stone of this establishment had been laid in October 1933, again the same year that Hitler came to power. In 1937 the premises were solemnly inaugurated with a "Great Exhibition of German Art," featuring mostly mediocre works all of which were of an unquestionable realism: still lifes, female nudes, landscapes and scenes exalting the vigor of the German race in the person of hard-working laborers, warrior-like soldiers or Nazi storm troopers. Parallel to this exhibition, which satisfied the NSDAP ideology, another one was organized by the Ministry of Propaganda under the concept of "Entartes Kunst" (Degenerate Art). This contained seventeen of Paul Klee's works, one of which was reproduced in the catalogue beside a painting which had been done by a schizophrenic, thus inducing the observer to draw the same conclusion as that of the powers-that-be.

However, this insult was offset to some extent that year by a series of satisfactions: his health had improved sufficiently to allow him to devote more time to his work,

so that in 1937 he completed 264 pieces. The artist had other reasons to be happy: at the beginning of the year he was to receive a visit from his old friend Kandinsky, who was living in Paris at the time and who had a major exhibition at the Kunsthalle in Bern, and in November he met up again with Picasso, who had traveled to Switzerland. In April of the following year he would receive a visit from Georges Braque.

In 1938 forty of Klee's paintings were exhibited in the Galerie Simon from January 14 to February 5. This exhibition was followed by another one in the French capital, containing twenty-three pieces, in the Galerie Balay et Carré from July 7 to 28. That same year his work was shown in New York on two occasions: in October (Nierendorf Galleries) and in November (Buchholz Gallery), while others of his pieces were included in a large exhibition of the Bauhaus artists in the Museum of Modern Art, also in New York.

Between March 3 and 16, 1939, examples of his work were to be shown in the London Gallery in the British capital; from May 15 to June 18 in the Neumann-Willard Gallery in New York; and in December in the Katherine Kuh Gallery in Chicago. In that fateful year of 1939, which in September saw the outbreak of World War Two, Paul Klee was able to make a deep study of the principal works from the Prado Museum, which at the end of the Spanish Civil War had been put under the custody of the League of Nations in Geneva by the Republican Government of Spain. The treasures contained in that country's largest art gallery and one of the best in Europe were exhibited in the Musée d'Art et d'Histoire in the city of Léman, an exhibition that the artist visited on two occasions. 1939 also marked a period of great activity for Klee, for despite his declining state of health he managed to execute 1,253 works, most of which were drawings.

The paintings from his final period, begun in 1936 and largely unfinished due to the death of the artist, differ substantially from his previous work. He used bright, ungraded colors and heavy strokes — generally in black — which plough through the composition. The art of Paul Klee is deliberately brutal. It could be said that the painter wished to reflect the unease he felt about his illness, which he knew to be incurable, and his anxiety about the political situation in his beloved Germany and the approaching world catastrophe he foresaw. Several of the titles he gives to his works reflect this state of depression: *Angstausbruch* (Outbreak of Fear), *Im Rausch* (Intoxication), *Tod und Feuer* (Death and Fire).

From January 3 to 11, 1940 one Klee exhibition was held in The Art Students League in New York and another in the Germanic Museum at Harvard University in Cambridge, Massachusetts from February 28 to March 27. At about the same time a major exhibition of his work was held in the Kunsthaus in Zurich from February 16 to March 25. In May he was hospitalized in a clinic in Orsolino (canton of Ticino), and he died on June 29, 1940 in Muralto, near Locarno, at the age of sixty.

He was cremated and his ashes buried in the cemetery of Schlosshalde, beneath a tombstone bearing a somewhat cryptic inscription which refers to the incomprehensibility of his existence, since he lived both with the dead and those as yet unborn.

Keys to an interpretation
of Klee's work

Paul Klee was an exceptional artist whose work bears no comparison with that of his contemporaries. He was an isolated figure in the panorama of innovative German painting of his time and, needless to say, also in relation to progressive plastic currents of the time in other countries. The isolation and uniqueness of Klee's work does not however imply that he evolved his concepts and style completely independent of the most advanced artists who became known to the European and North American public during the first three decades of this century. He did not live as a recluse in an ivory tower. The foregoing pages attest to his friendships with Wassily Kandinsky, Franz Marc, August Macke, Robert Delaunay, Alexei Jawlensky, Lyonel Feininger, Georges Braque, and Pablo Picasso, especially with the first four, whom he held in especially high esteem.

The personality of Paul Klee stood out by virtue of his uncommonly great individuality, and in order to attempt to define his art it might be expedient to begin by affirming that, except in his formative years, he never tried to reproduce or imitate natural forms. He was not in any way a realist; indeed, he could not have been, for as an artist of his own time he was conscious that at the end of the preceding century the Impressionists had carried realistic painting to its glorious apotheosis. Neither did Paul Klee belong to that group of painters who, through the influence of Cézanne, rationalized the plastic arts, such as the Cubists, Constructivists, and Purists, although he did very much admire the work of Robert Delaunay, the Cubist who tended towards Orphism in an attempt to humanize geometrical painting.

Within the framework of its characteristic individuality, however, the art of Paul Klee can to an extent be included in the trend of contemporary German painting in which the form, the drawing, is less important than color, which the painters apply exaggeratedly and violently to accentuate the expressive quality of their work in a manner similar to that of the French *fauves* (Matisse, Derain, Vlaminck, Marquet, Dufy), but with greater force, even possibly with deliberate brutality. This tendency can in general be described as "expressionist," and among its followers were Emile Nolde, the painters of Die Brucke (The Bridge), principally Ernst Ludwig Kirchner and Karl Schmidt-Rottluf, a group which Nolde joined for a short time, the painters of the Munich Neue Kunstlervereinigung, founded by Kandinsky and to which Franz Marc belonged, and the artists who later formed "Der Blaue Reiter," a group in which as we know Klee played an active part. This is the trend that German painting followed from approximately five years prior to the First World War until the rise of Nazism, a trend in which color has priority over form and to which the art of Paul Klee can to an extent be ascribed.

Furthermore, the Parisian Surrealists greatly admired the work of the painter from the other side of the Rhine who was in no way influenced by what he saw in the visible world, although frankly I do not know to what extent the artist himself was aware that he was considered as belonging to that group. Therefore if the Surrealists

decided to include Klee in their ranks it was because the painter worked in the knowledge that there should be no distinction between the real and the imaginary, between the interior and exterior worlds, since rather than contrasting concepts they both form integral parts of the unity of the Cosmos. There is, then, a mystic under-current in the art of Paul Klee, although we know for certain that he did not share the enthusiasm his very close friend Kandinsky felt for a time for the theosophist Rudolf Steiner.

According to Klee the mission of the artist is to describe cosmic unity in a sensitive way, with the greatest technical precision, pouring onto the canvas or the paper what belongs to the invisible world using apparently shaky lines — as if produced by a seismograph — and responding to the tiniest impulse of the psyche (it should be remembered that Paul Klee's work began to develop at a time when Sigmund Freud's research on psychoanalysis was becoming known). These lines, which at times can be disconcertingly realistic, on other occasions make use of features that bear no relation to nature. Nevertheless, they are suggestive of the beginnings of concrete shapes.

This might explain his admiration for the spontaneous creations of children and primitive peoples, in which imitation of the real world is mixed with babblings and simulations. The art of Paul Klee is at once abstract and representative. Profound and subtle. Unrepeatable, since it emanated from a soul that has no equal. Few painters attained the stature of Klee either in his country or his time.

Brief chronology

1879. Paul Klee is born on December 18 in München-bruchsee, in the canton of Bern (Switzerland) to Hans Wilhelm Klee and Marie Ida Frick.

1898. He completes his studies at the "Gymnasium" in Bern. Admitted to Heinrich Knirr's studio, where he prepares for entrance into the Fine Arts Academy in Munich.

1901. Concludes his studies at the Academy. Travels to Italy.

1902. First etchings.

1905. Trip to Paris (in June).

1906. Travels to Berlin (in April). Contributes ten etchings to the Sezession exhibition in Munich in June. On September 15 marries Karoline ("Lily") Stumpf, a pianist. The couple take up residence in the Schwabing district of Munich.

1907. Felix Klee is born in November.

1908. Contributes three engravings to the Sezession exhibition held in Munich in May and six to the exhibition held in Berlin in October.

1909. Exhibits fifty-six works of different techniques in the Kunstmuseum of Bern in August, a show which later travels to Zurich, Winterthur and Basel (until the end of 1910).

1911. Exhibits thirty drawings in the Tannhauser Gallery in Munich (June).

1912. Participates in the "Der Blaue Reiter" group exhibition in the Hans Goltz Gallery in Munich (February), in the Sema group exhibition at the Tannhauser Gallery (April) and another group exhibition at the Der Sturm Gallery in Berlin (April–May). Second trip to Paris (April).

1913. Klee's translation of Robert Delaunay's essay *Sur la lumière,* entitled *Uber das Licht,* appears in the weekly journal on art and culture *Der Sturm,* published in Berlin (April). The same journal publishes one of Klee's drawings in December.

1914. Travels to Tunisia (April). Participates in the new Munich Sezession exhibition held in May.

1916. Klee is drafted and sent to the infantry regiment (March). Visits Switzerland.

1917. Klee is assigned to the air force pilot training school (January).

1918. The artist takes up residence with his family in the Palais Suresnes in Munich (November).

1919. Becomes a member of the Arts Council of the Communist Republic of Bavaria (April). Signs a contract with the art dealer Hans Goltz. Curt Corrinth's book *Potsdamer Platz, oder die Nächte des Neuen Messias* is published with ten illustrations by Paul Klee.

1920. Exhibits 365 works in various techniques at Hans Goltz's Neue Kunst Gallery in Munich (May). Contracted as a teacher by the Weimar Bauhaus (October). The German translation of Voltaire's *Candide* is published with twenty-six pen and ink illustrations by Klee.

1921. Begins teaching at the Bauhaus (January). The artist settles with his family in Weimar (September). Publication of Wilhelm Hausenstein's book, *Kairuan, oder eine Geschichte vom Maler Klee und von der Kunst dieses Zeitalters,* the first study of Klee's work.

1923. Participates in the first Bauhaus exhibition and festival, for which he designs a poster and an invitation card (August–September). Exhibits at the Kronprinzpalais in Berlin. Spends his holidays by the North Sea.

1924. One-man show in New York organized by the Société Anonyme (January–February). Gives a lecture on modern art at the Art Union of the University of Jena (January). Visits Sicily. The Bauhaus in Weimar is closed (December).

1925. Klee's *Pädagogisches Skizzen-Buch,* based on his class notes at the Bauhaus is published. Retrospective exhibition of his work over the past

five years at the Neue Kunst Gallery in Munich and in the Galerie Vavin-Raspail in Paris (October–November). Exhibits jointly with Jawlensky, Feininger and Kandinsky at the Daniel Gallery in New York and contributes to the exhibition of surrealist painting at the Galerie Pierre in Paris (November). Signs a contract with the art dealer Alfred Flechtheim.

1926. Takes up residence with his family in Dessau (July). Travels to the south of Italy. The new Bauhaus is inaugurated (December).

1927. Exhibits at Albert Flechtheim's gallery in Düsseldorf. Visits the south of France and Corsica.

1928. Exhibits at Albert Flechtheim's gallery in Düsseldorf (November) and at the Le Centaure exhibition hall in Brussels (December). Travels to Brittany and to Egypt.

1929. Exhibits at the Galerie Georges Bernheim-Jeune in Paris (January) and in the Neue Kunst Fides Gallery in Dresden (February–March). Visits the south of France. Exhibits at the Galerie Alfred Flechtheim in Berlin. Publication of the French version of Will Grohmann's monograph on Klee.

1930. Exhibits at the Galerie Alfred Flechtheim in Düsseldorf, at the Nationalgalerie in Berlin, at the Museum of Modern Art in New York and at the Braxton Gallery in Hollywood. Participates in a group exhibition of German artists in Cambridge, Massachusetts.

1931. Begins his work as member of the teaching staff of the Düsseldorf Academy of Art (April). Exhibits at the Kestner-Gesellschaft in Hannover, at the Kunstverein für Rheinland und Westfallen in Düsseldorf, and at the Galerie Alfred Flechtheim in Berlin. Participates in a group exhibition of German artists in New York, Buffalo and San Francisco. Visits northern Italy.

1933. Paul Klee is suspended from his teaching post at the Academy of Art in Düsseldorf. Travels in the south of France. Signs a contract with the art dealer D.-H. Kahnweiler in Paris. The National Socialist government removes his work from all German museums. He settles with his family in his family home in Bern (December).

1934. Exhibits at the Mayor Gallery in London (January) and at D.-H. Kahnweiler's Galerie Simon (June). A book by Will Grohmann on Klee's drawings is confiscated.

1935. Exhibits at the Mayor Gallery in London (January), at the Kunsthalle in Bern (February–March), at the Contemporary Circle in New York (March), in Oakland, California (October), and at the Kunsthalle in Basel (October–November). First symptoms of a serious illness.

1936. Exhibits at the Wadsworth Athenaeum in Hartford, Connecticut (January–February).

1937. Participates in group exhibitions at the East River Gallery in New York, at the Putzel Gallery in Los Angeles and at the Museum of San Francisco. Seventeen of Paul Klee's works are included in the *Entartete Kunst* (Degenerate Art) exhibition organized in Munich by the National Socialist government.

1938. Exhibits at the Galerie Simon in Paris (January–February), at the Balay et Carré exhibition rooms in the same city (July), at the Nierendorf Galleries in New York (October) and at the Buchholz Gallery, also in New York (November). Participates in a Bauhaus artists exhibition at the Museum of Modern Art in New York.

1939. Exhibits at the London Gallery, London (March), at the Newmann-Willard Gallery in New York (June), and at the Katharina Kuh Gallery, Chicago (December).

1940. Exhibits at the Art Students League in New York (January), at the Germanic Museum in Cambridge, Massachusetts (February–March) and at the Kunsthaus of Zurich (February–March). On June 29 Paul Klee dies in Muralto, in the Swiss canton of Ticino.

Bibliography

Writings of Paul Klee

Pädagogisches Skizzen-Buch. Munich: Langen, 1925.

Über die Moderne Kunst. Bern: Benteli, 1945.

Journal. Paris: Grasset, 1959.

Théorie de l'art moderne. Genoa: Gontier, 1968.

Écrits sur l'art (ed. by J. Spiller), Paris, 1977, 2 vol.

On the Work of Paul Klee

ALFIEŔI, Bruno. *Paul Klee.* Venice: Istituto Tipografico, 1948.

CASSOU, Jean. *Hommage à Paul Klee.* Boulogne-sur-Seine: L'Architecture d'Aujourd'hui, 1949.

COOPER, Douglas. *Paul Klee.* Harmondsworth: Penguin Books, 1949.

CREVEL, René. *Paul Klee.* Paris: Gallimard, 1930.

GEELHAR, Christian. *Paul Klee et le Bauhaus.* Paris: Neuchâtel, 1972.
Paul Klee. Leben und Werk. Cologne: Du Mont Schauberg, 1974.
Paul Klee. Dessins. Paris, 1975.

GROHMANN, Will. *Paul Klee.* Paris: Éd. des Cahiers d'Art, 1929.

HAUSENSTEIN, Wilhelm. *Kairuan, oder eine Geschichte vom Maler Klee und von der Kunst dieses Zeitalters.* Munich: Kurt Wolff, 1921.

KAHNWEILER, Daniel-Henry. *Klee.* Paris: Braun, 1950.

KLEE, Felix. *Paul Klee. Leben und Werk in Dokumenten.* Zurich: Diogenes Verlag, 1960.

READ, Herbert. *Paul Klee (1879–1940).* London: Faber and Faber, 1948.

ILLUSTRATIONS

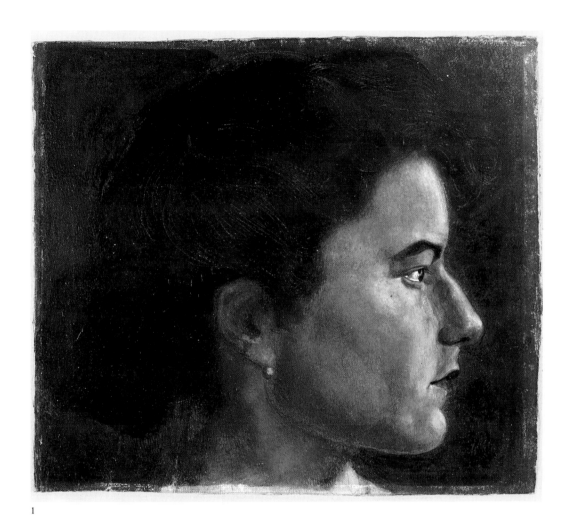

1

1. *The Artist's Sister*. 1903.
 (Die Schwester des Künstlers)
 Oil and watercolor on cardboard,
 10¾ × 12½ in. (27.5 × 31.5 cm).
 Klee Foundation, Kunstmuseum, Bern.

2. *Portrait of My Father*. 1906.
(Bildnis meines Vaters)
India ink on glass (painted on the back),
12×11½ in. (32×29 cm).
Felix Klee Collection, Bern.

3. *Merman as Fetishist*. 1907.
(Der Wassermann als Fetischist)
Paint and watercolor on glass (painted on the back),
5×7 in. (12.9×17.7 cm).
Klee Foundation, Kunstmuseum, Bern.

4. *Virgin in a Tree*. 1903
(Jungfrau im Baum)
Etching,
9¼×11¾ in. (23.6×29.6 cm).
Klee Foundation, Kunstmuseum, Bern.

5. *Gentleman and Lady in a Loge*. 1908.
(Herr und Dame in der Loge)
Black paint and watercolor on glass (painted on the back),
5×7 in. (12.9×17.8 cm).
Klee Foundation, Kunstmuseum, Bern.

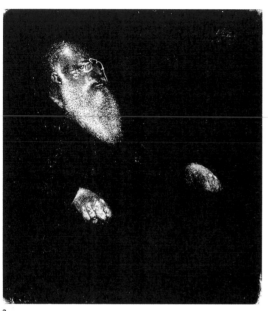

2

3

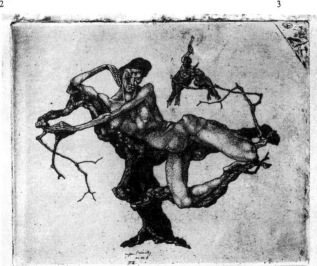

4

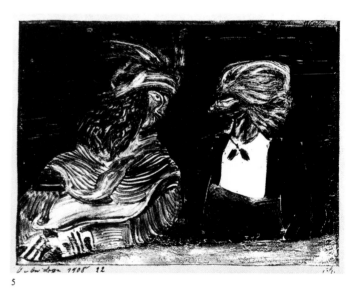

5

6. *In the Quarry at Ostermundigen, Two Cranes*. 1907.
(Im Ostermundigen Steinbruch, zwei Kräne)
Charcoal, India ink and watercolor on paper mounted on cardboard,
24³/₄ × 19¹/₈ in. (63.1 × 48.6 cm).
Klee Foundation, Kunstmuseum, Bern.

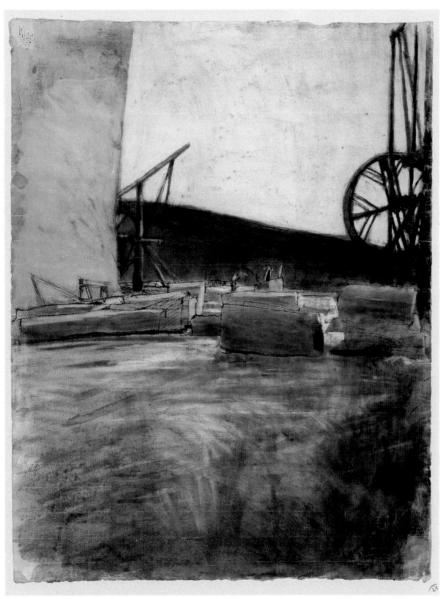

6

7. *In the Quarry*. 1913.
 (Im Steinbruch)
 Watercolor on paper mounted on cardboard,
 8³/₄ × 13⁷/₈ in. (22.3 × 35.2 cm).
 Klee Foundation, Kunstmuseum, Bern.

8. *Female Nude (to the Knees)*. 1910
 (Weiblicher Akt - bis zu den Knien)
 Oil on muslin mounted on cardboard,
 15³/₈ × 9⁷/₈ in. (38.9 × 25 cm).
 Klee Foundation, Kunstmuseum, Bern.

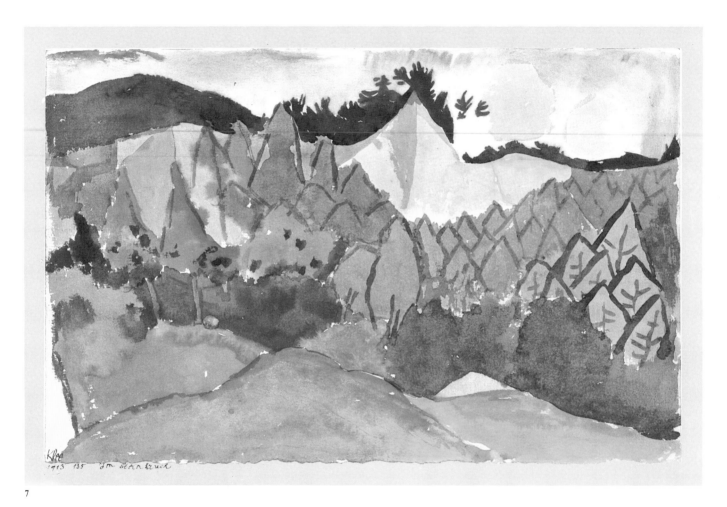

7

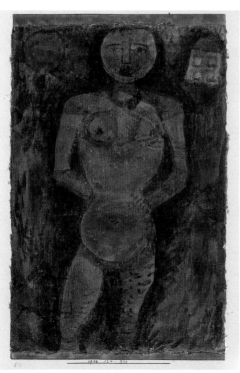

8

9. *Houses near the Gravel Pit (Sketched from Nature)*. 1913.
 (Häuser an der Kiesgrube - Naturskizze)
 Watercolor on paper mounted on cardboard,
 6⅛ × 6½ in. (15.6 × 16.7 cm).
 Klee Foundation, Kunstmuseum, Bern.

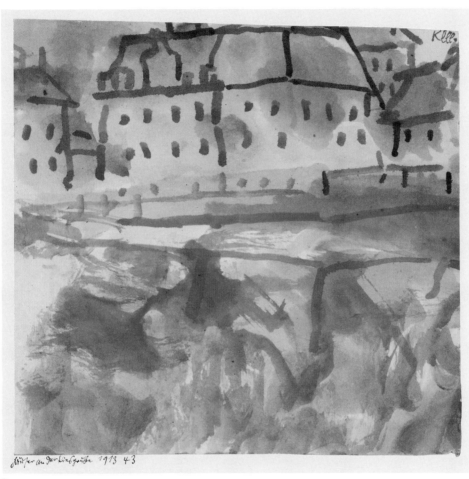

9

10. *Saint-Germain, near Tunis*. 1914.
(Saint-Germain, près de Tunis)
Watercolor on paper mounted on cardboard,
8½×12¾ in. (21.6×32.4 cm).
Musée National d'Art Moderne, Paris.

11. *Before the Gates of Kairouan*. 1914.
(Vor den Toren von Kairouan)
Watercolor on paper mounted on cardboard,
8⅛×12⅜ in. (20.7×31.5 cm).
Klee Foundation, Kunstmuseum, Bern.

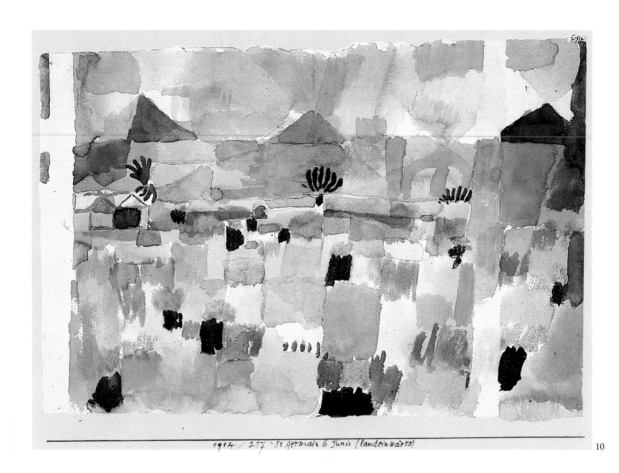

10

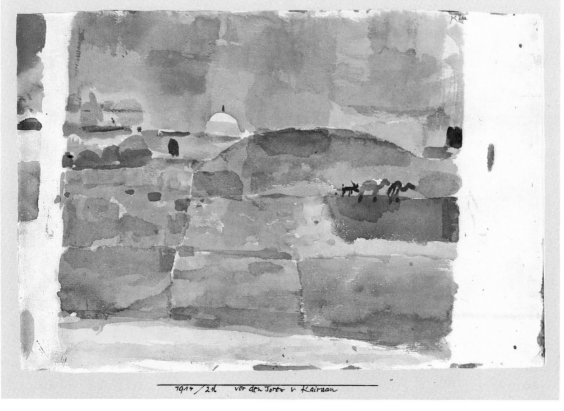

11

12. *Motif from Hammamet.* 1914.
 (Motiv aus Hammamet)
 Watercolor on paper mounted on cardboard,
 8 × 6⅛ in. (20.2 × 15.7 cm).
 Öffentliche Kunstsammlung Basel, Kunstmuseum.

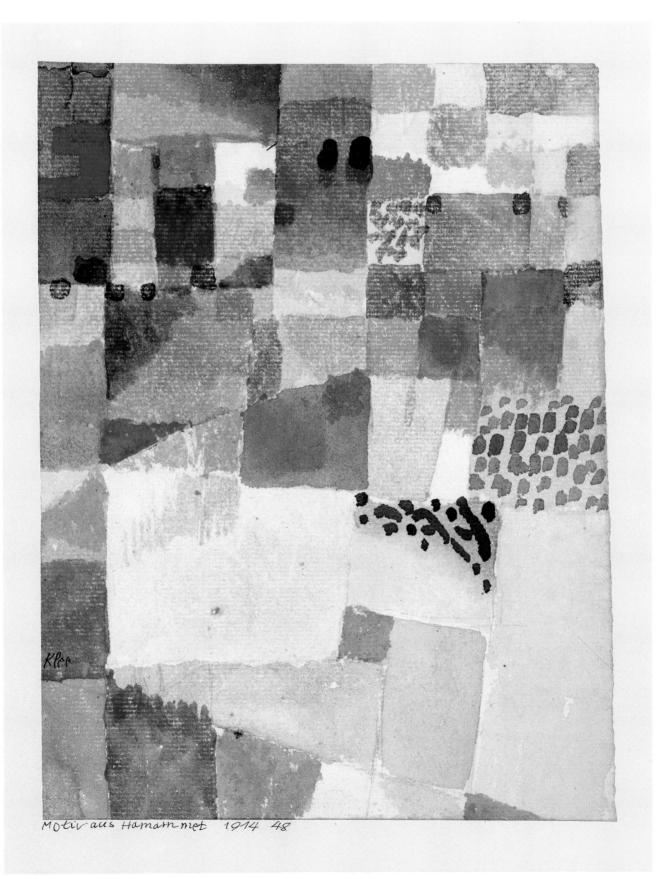

13. *Quarry at Ostermundigen*. 1915.
 (Steinbruch Ostermundigen)
 Watercolor on paper mounted on cardboard,
 8 × 9⅝ in. (20.2 × 24.6 cm).
 Klee Foundation, Kunstmuseum, Bern.

14. *Once Emerged from the Gray of Night...* 1918.
 (Einst dem Grau der Nacht enttaucht...)
 Watercolor on paper mounted on cardboard,
 8⅞ × 6⅛ in. (22.6 × 15.8 cm).
 Klee Foundation, Kunstmuseum, Bern.

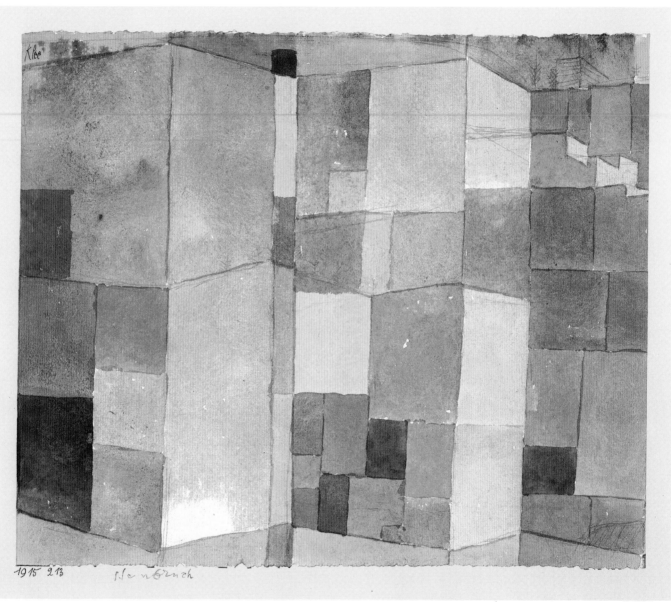

13

Einst dem Grau der Nacht enttaucht / Dem schwer und teuer / und stark vom Feuer /
Abends voll von Gott und gebeugt // Nun ätherlings vom Blau umschauert, / entschwebt
über Firnen, zu klugen Gestirnen.

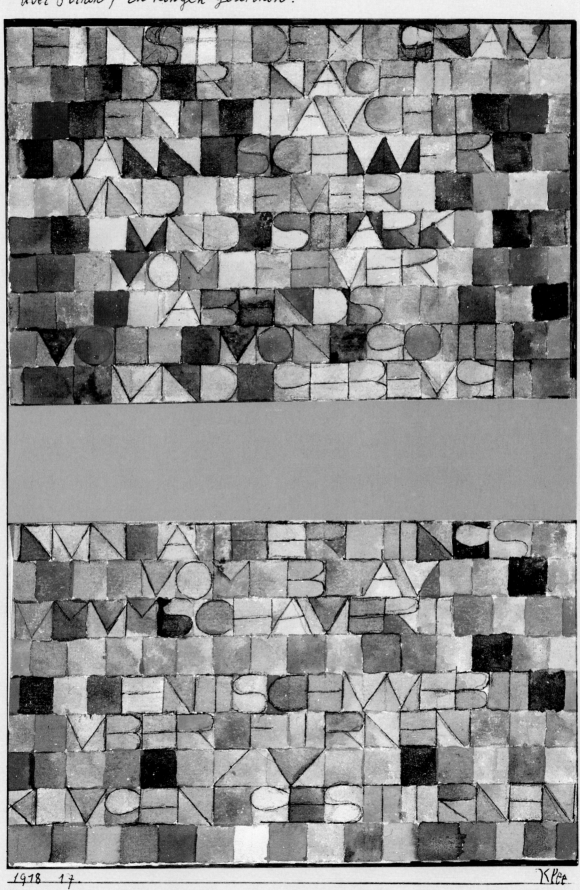

1918 17. Klee

14

15. *Irma Rossa, the Animal Tamer*. 1918.
 (Irma Rossa die Bändigerin)
 Watercolor and India ink on paper mounted on cardboard,
 $11^{5}/_{8} \times 9$ in. (29.5 × 23 cm).
 Sprengel Museum, Hannover.

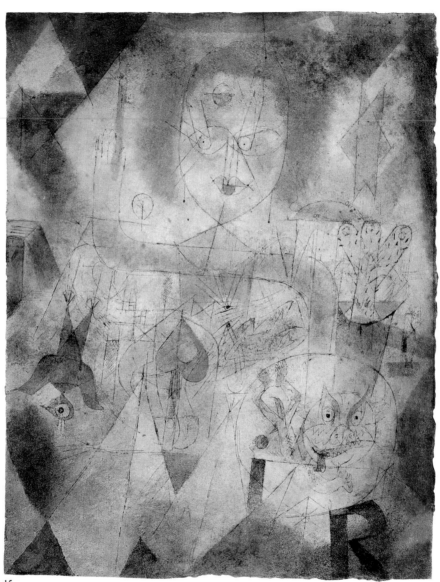

15

16. *Statuette.* 1916.
 (Statuette)
 Gypsum, wood and watercolor,
 14$^{1}/_{8}$ × 2$^{1}/_{2}$ × 3$^{1}/_{8}$ in. (36 × 6.5 × 8 cm).
 Klee Foundation, Kunstmuseum, Bern.

17. *Statuette.* 1919.
 (Statuette)
 Polished tile, gypsum, wood, watercolor and India ink,
 6$^{7}/_{8}$ × 2$^{3}/_{4}$ × 2$^{3}/_{4}$ in. (17.5 × 7 × 7 cm).
 Klee Foundation, Kunstmuseum, Bern.

18. *Statuette.* 1919.
 (Statuette)
 Polished tile, gypsum, wood, watercolor and India ink,
 12 × 5$^{3}/_{8}$ × 2$^{1}/_{2}$ in. (30.5 × 13.5 × 6.5 cm).
 Klee Foundation, Kunstmuseum, Bern.

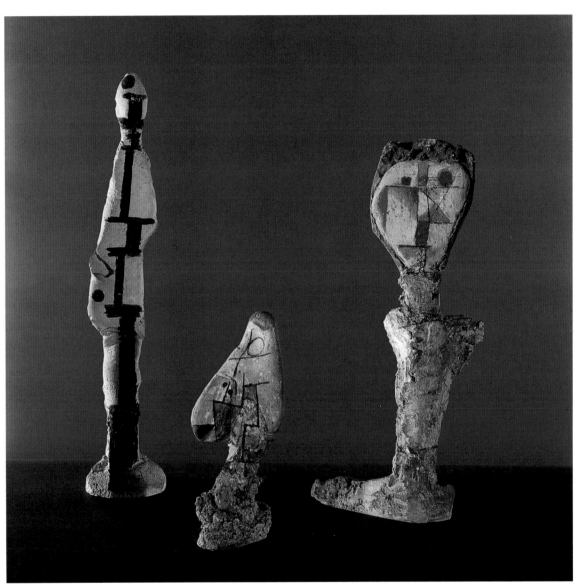

16 17 18

19. *Architecture with a Window.* 1919.
 (Architektur mit dem Fenster)
 Oil and India ink on paper mounted on board,
 19³⁄₈ × 16³⁄₈ in. (50 × 41.5 cm).
 Klee Foundation, Kunstmuseum, Bern.

20. *City Architecture with Green Church Tower.* 1919.
 (Städtebau mit grünem Kirchturm)
 Watercolor and gouache on paper mounted on cardboard,
 12 × 5¹⁄₈ in. (30.3 × 13 cm).
 Klee Foundation, Kunstmuseum, Bern.

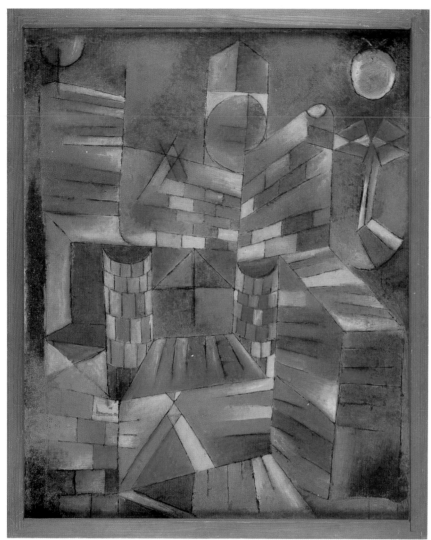

19

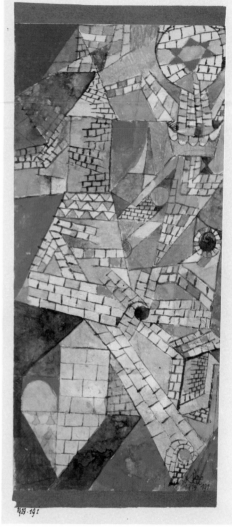

20

21. *Station L 112, 14 km.* 1920
(Station L 112, 14 km.)
Watercolor and India ink on paper mounted on cardboard,
4⅞ × 8½ in. (12.3 × 21.8 cm).
Kunstmuseum, Bern. Hermann and Margrit Rupf Foundation.

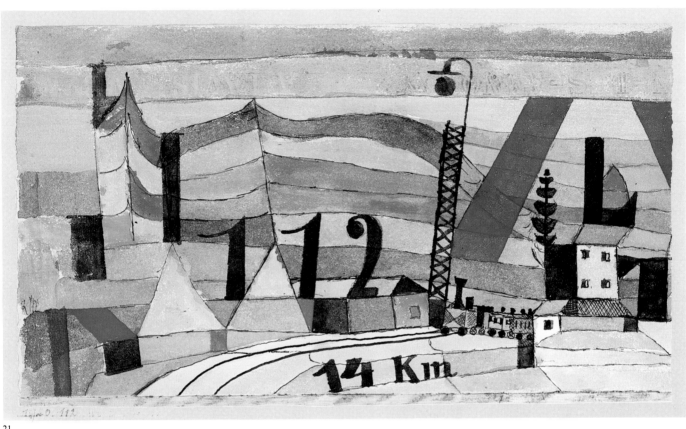

21

22. *An Angel Serves a Small Breakfast*. 1920.
 (Ein Genius serviert ein kleines Frühstück)
 Lithograph,
 7¾ × 5¾ in. (19.8 × 14.6 cm).
 Sprengel Museum, Hannover.

23. *Plan for a Garden Architecture*. 1920.
 (Plan einer Gartenarchitektur)
 Watercolor and oil on canvas mounted on cardboard,
 14⅜ × 16⅞ in. (36.5 × 42.9 cm).
 Klee Foundation, Kunstmuseum, Bern.

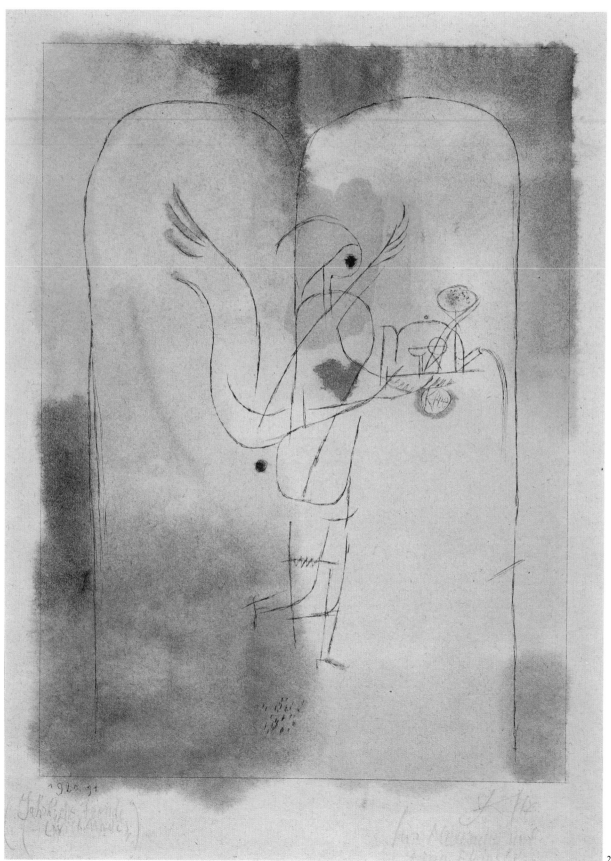

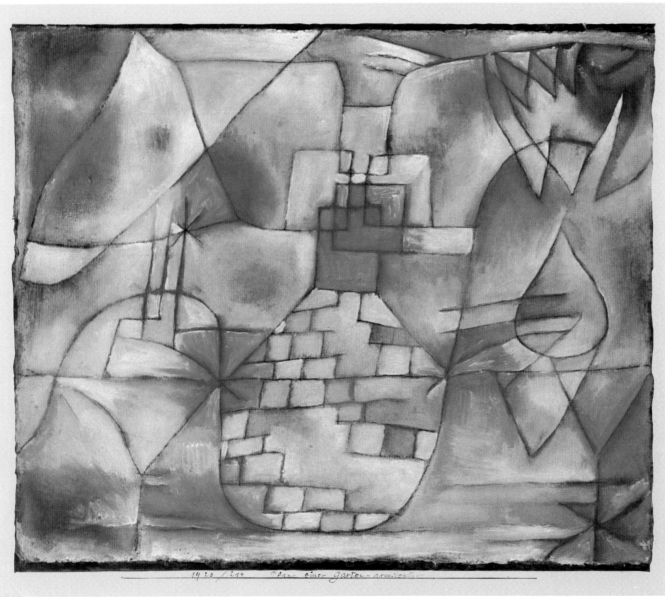

1920 / 314 Plan einer Garten-architektur.

23

24. *Islands of the Birds*. 1921.
 (Vogel-Inseln)
 Watercolor and oil on paper mounted on cardboard,
 12⅛ × 18 in. (30.8 × 45.8 cm).
 Klee Foundation, Kunstmuseum, Bern.

25. *Crystal Gradation*. 1921.
 (Kristall-Stuffung)
 Watercolor on paper mounted on cardboard,
 9⅝ × 12⅜ in. (24.5 × 31.5 cm).
 Kunstmuseum, Basel.

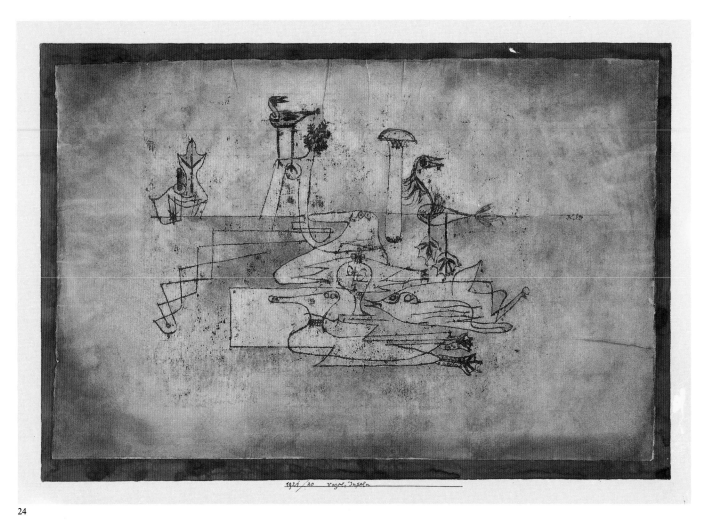

24

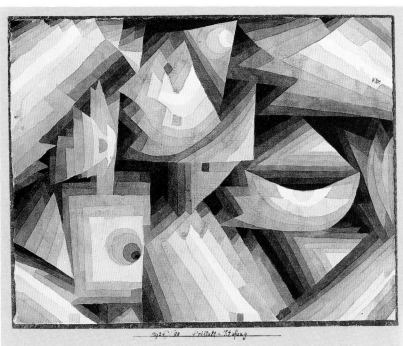

25

26. *Tale à la Hoffmann*. 1921.
(Märchen à la Hoffmann)
Watercolor on paper mounted on fine cardboard,
12¼ × 9½ in. (31.1 × 24.1 cm).
The Metropolitan Museum of Art, New York.
The Berggruen Klee Collection.

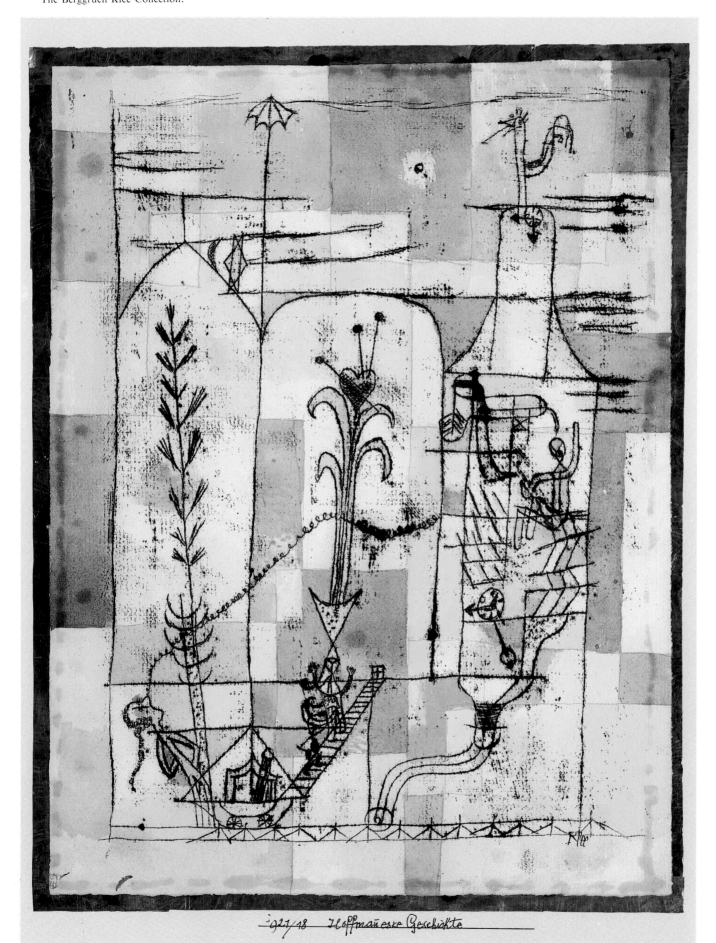

27. *The Vessels of Aphrodite, or: Ceramic-Erotic-Religious.* 1921.
(Die Gefässe der Aphrodite, oder: Keramisch/erotisch/religiös)
Watercolor on paper mounted on cardboard,
18¼ × 11⅞ (46.3 × 30.1 cm).
Klee Foundation, Kunstmuseum, Bern.

28. *Room Perspective with Inhabitants.* 1921.
(Zimmerperspektive mit Einwohnern)
Watercolor and oil on paper mounted on cardboard,
19 × 12½ in. (48.5 × 31.7 cm).
Klee Foundation, Kunstmuseum, Bern.

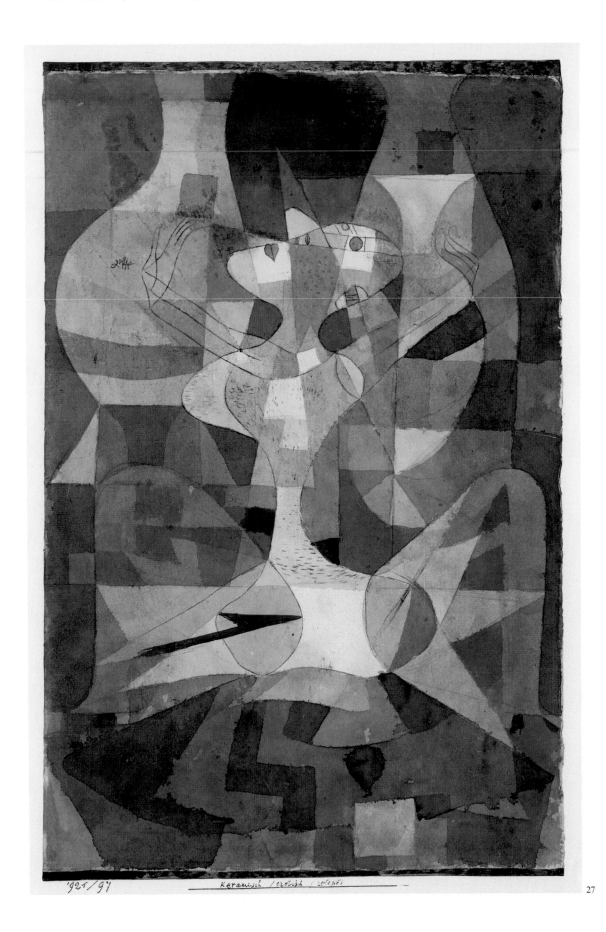

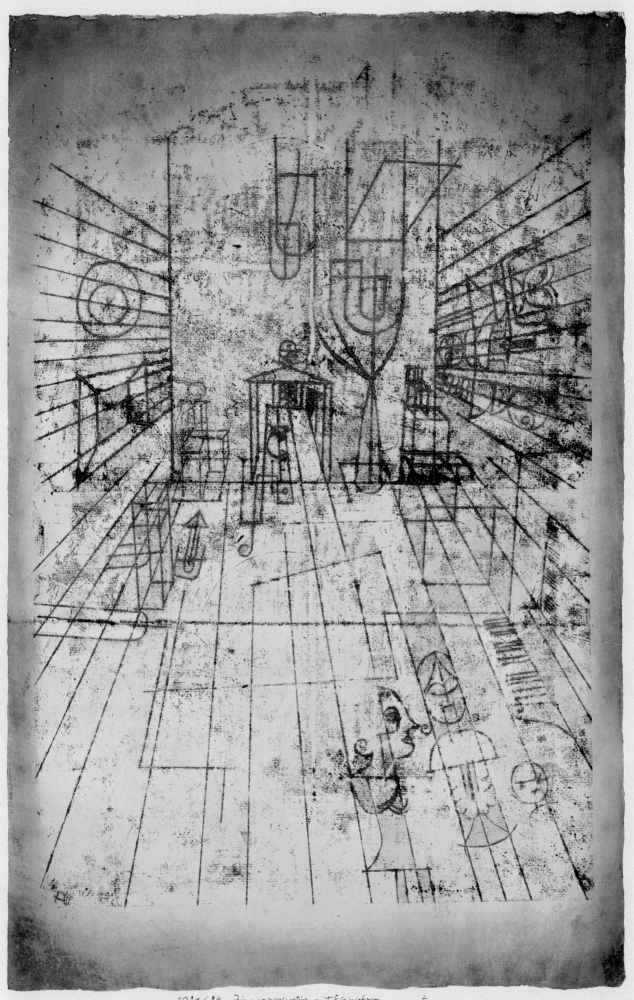

1927/24 Zimmer perspective mit Einwohnern

29. *Garden Plan*. 1922.
 (Garten-Plan)
 Watercolor and India ink on paper mounted on cardboard,
 10½ × 13⅛ in. (26.6 × 33.5 cm).
 Klee Foundation, Kunstmuseum, Bern.

30. *Mural from the Temple of Longing*. 1922.
 (Wandtafel für den Longingtempel)
 Watercolor, printer's ink and plastered canvas mounted on fine cardboard,
 10½ × 14¾ in. (26.7 × 37.5 cm).
 The Metropolitan Museum of Art, New York.

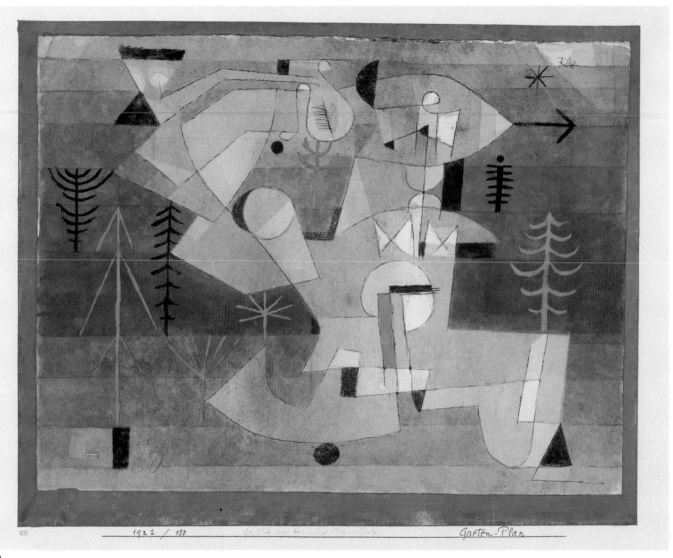

29

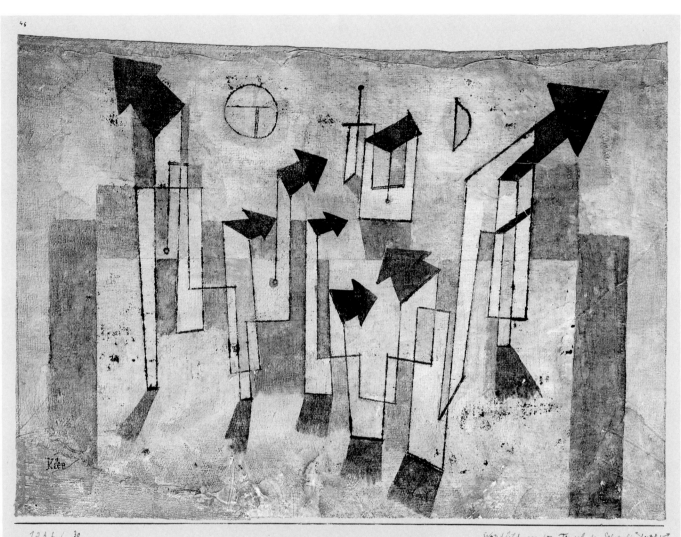

31. *Stricken Place*. 1922.
(Betroffener Ort)
Watercolor, India ink and pencil on paper mounted on cardboard,
13×9 in. (32.8×23.1 cm).
Klee Foundation, Kunstmuseum, Bern.

32. *Genii (Figures from a Ballet)*. 1922.
(Genien. Figuren aus einem Ballett)
Watercolor and pencil on paper mounted on cardboard,
10⅛×6⅞ in. (25.7×17.4 cm).
Klee Foundation, Kunstmuseum, Bern.

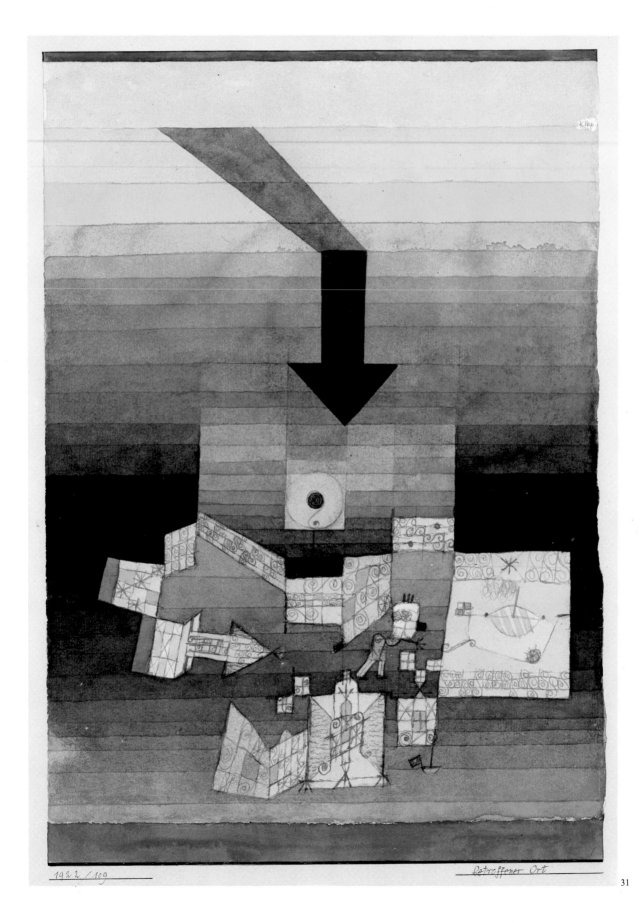

Genii (Figures from a Ballet). 1922.

1922 / 109 Betroffener Ort

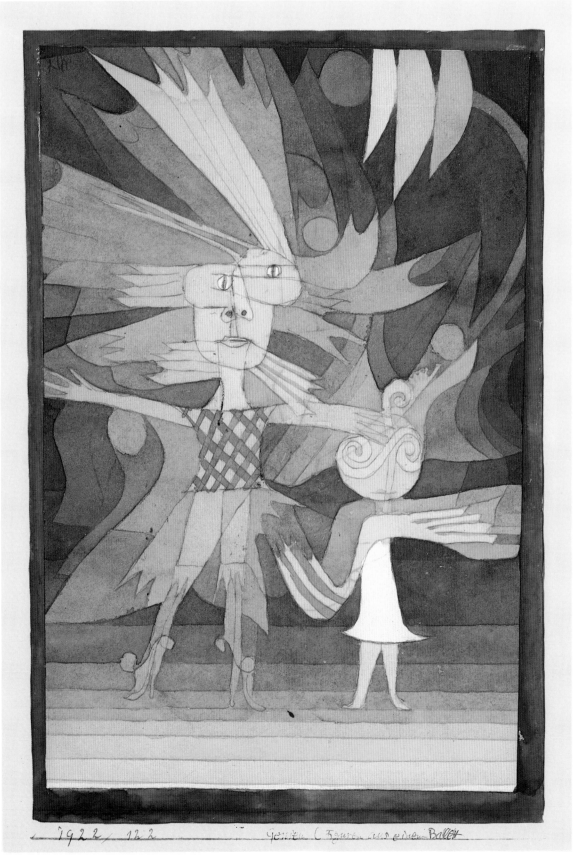

1922/122 Genien (Figuren aus einem Ballet

33. *Unstable Equilibrium*. 1922.
 (Schwankendes Gleichgewicht)
 Watercolor and pencil on paper mounted on cardboard,
 13½ × 7 in. (34.5 × 17.8 cm).
 Klee Foundation, Kunstmuseum, Bern.

34. *Castle in the Air*. 1922.
 (Luftschloss)
 Oil and watercolor on plastered gauze mounted on cardboard,
 24⅝ × 16 in. (62.6 × 40.7 cm).
 Kunstmuseum Bern. Hermann and Margrit Rupf Foundation.

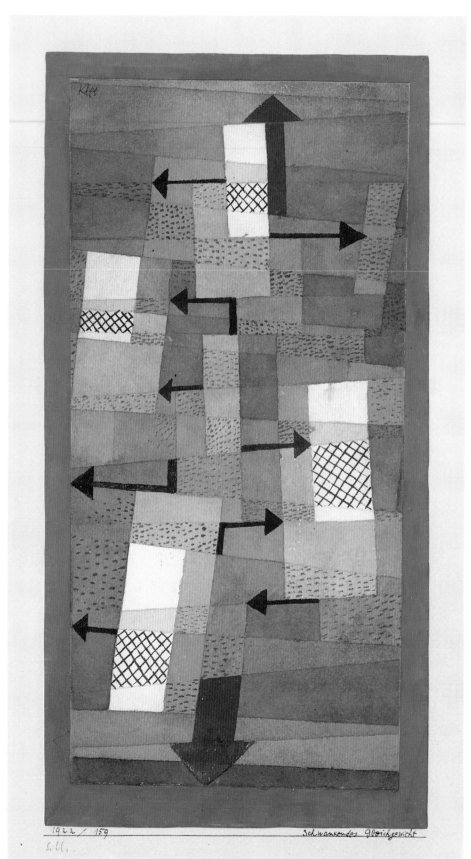

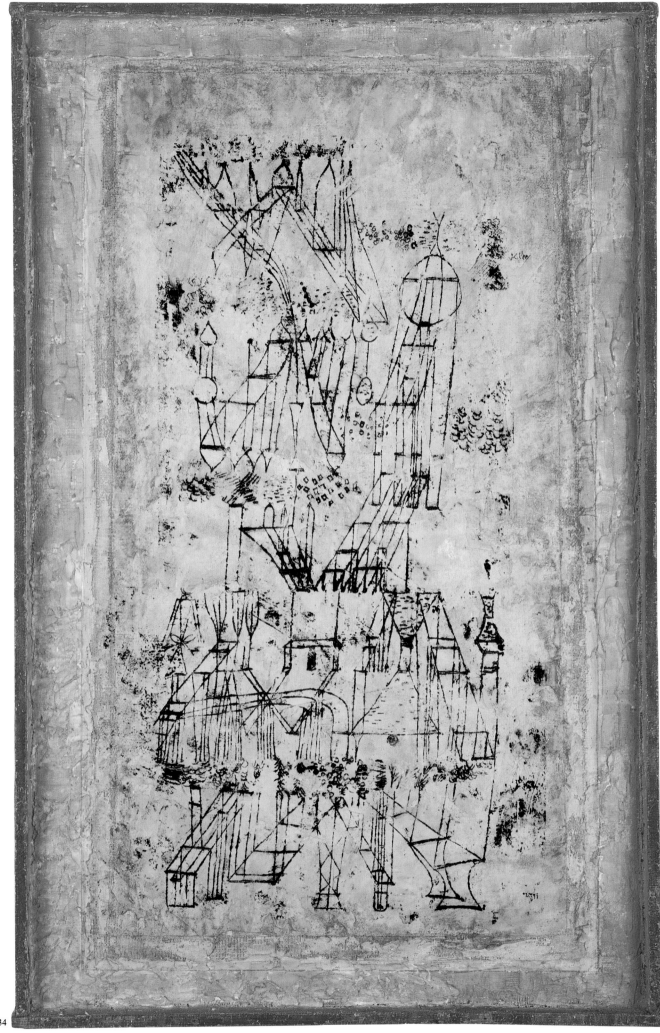

34

35. *Analysis of Diverse Perversities*. 1922.
 (Analyse verschiedener Perversitäten)
 Watercolor and India ink on paper mounted on cardboard,
 12¼×9½ in. (31×24 cm).
 Musée National d'Art Moderne, Paris.

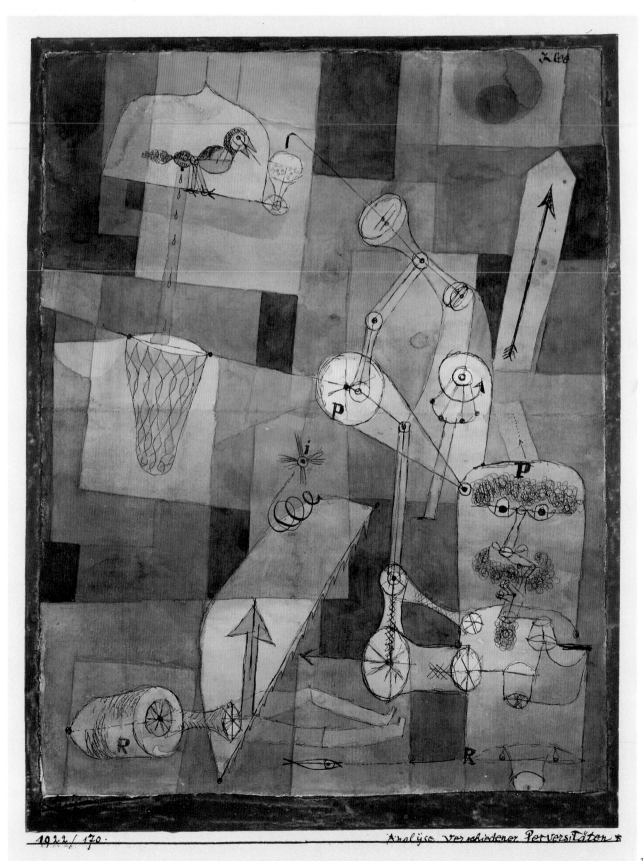

36. *God of the Northern Forest*. 1922.
 (Der Gott des nördlichen Waldes)
 Oil and India ink on canvas mounted on cardboard,
 21 × 16¼ in. (53.5 × 41.4 cm).
 Klee Foundation, Kunstmuseum, Bern.

37. *Vocal Fabric of the Singer Rosa Silber*. 1922.
 (Das Vokaltuch der Kammersängerin Rosa Silber)
 Watercolor and plaster on muslin, mounted on cardboard,
 24½ × 20½ in. (62.3 × 52.1 cm).
 Collection, The Museum of Modern Art, New York.
 Gift of Mr. and Mrs. Stanley Resor.

36 37

38. *Twittering Machine*. 1922.
 (Zwitscher-Maschine)
 Watercolor, pen and ink oil transfer drawing,
 25¼ × 19 in. (63.8 × 48.1 cm).
 Collection, The Museum of Modern Art, New York. Purchase.

39. *Ventriloquist and Crier in the Moor*. 1923.
 (Bauchredner und Ausrufer im Ödland)
 Watercolor and printer's ink on paper mounted on fine cardboard
 15¼ × 12 in. (38.7 × 27.9 cm).
 The Metropolitan Museum of Art, New York.
 The Berggruen Klee Collection.

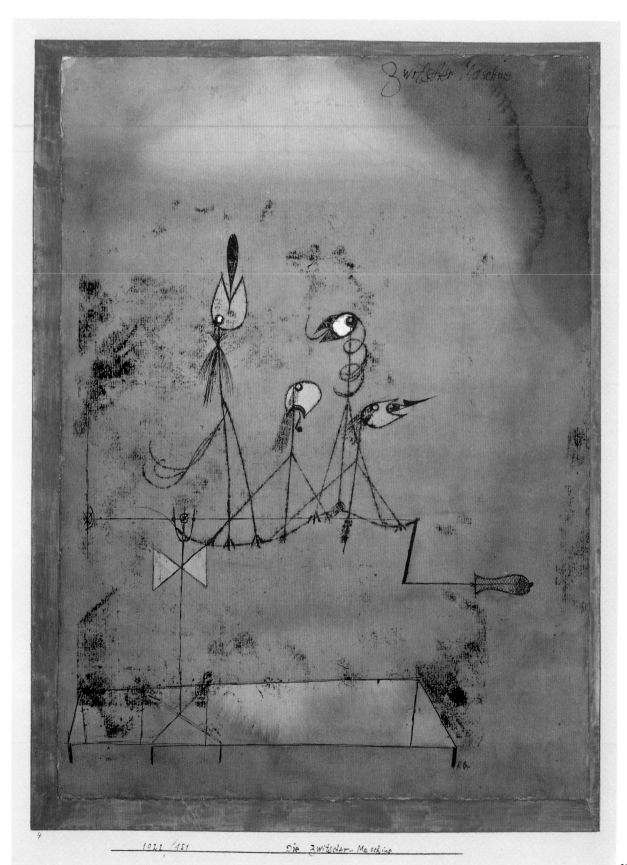

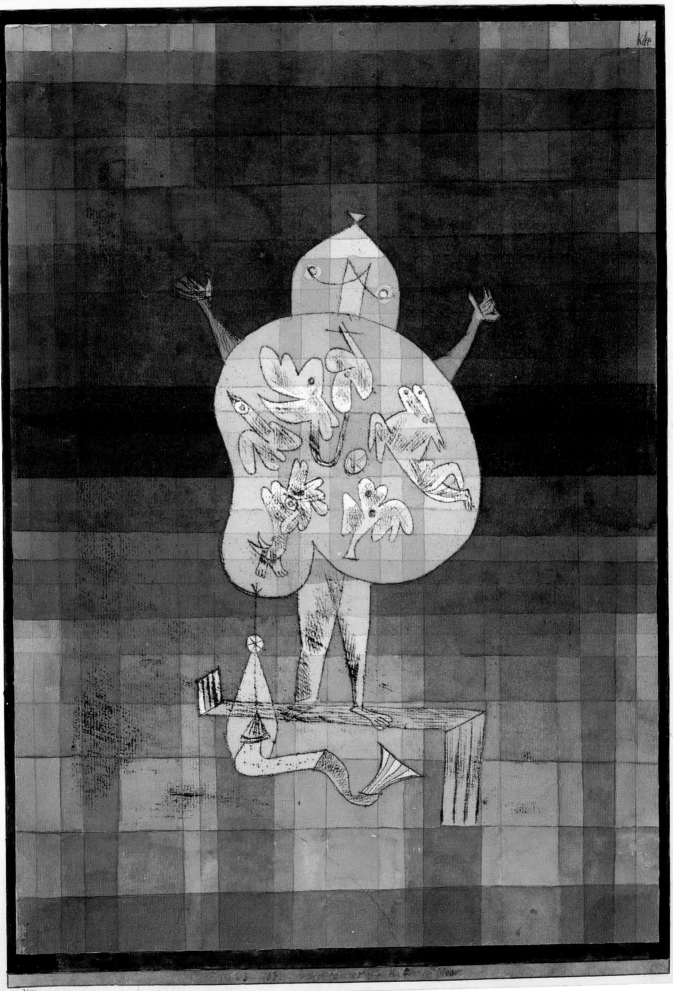

40. *North Sea Picture (from Baltrum).* 1923.
 (Nordseebild, aus Baltrum)
 Watercolor on paper mounted on cardboard,
 9¼ × 12⅜ in. (24.7 × 31.5 cm).
 Klee Foundation, Kunstmuseum, Bern.

40

41. *Magic Theater*. 1923.
 (Zaubertheater)
 India ink and watercolor on paper mounted on cardboard,
 13¼×9 in. (33.6×22.8 cm).
 Klee Foundation, Kunstmuseum, Bern.

42. *Strange Garden*. 1923.
 (Seltsamer Garten)
 Watercolor on plastered canvas mounted on fine cardboard,
 15¾×11⅜ in. (40×28.9 cm).
 The Metropolitan Museum of Art, New York.
 The Berggruen Klee Collection.

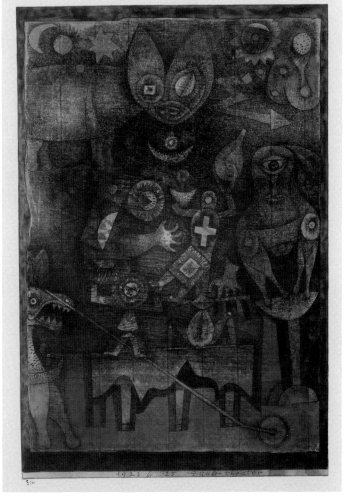

41

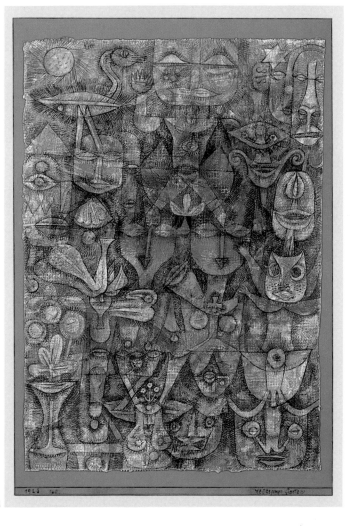

42

43. *17, Astray.* 1923.
(Siebzehn, irr.)
Watercolor and India ink on paper mounted on cardboard,
8⅞×11¼ in. (22.5×28.5 cm).
Öffentliche Kunstsammlung Basel, Kunstmuseum.

44. *The Tightrope Walker.* 1923.
(Der Seiltänzer)
Watercolor, oil, pencil and India ink on paper mounted on cardboard,
19⅛×12⅝ in. (48.7×32.2 cm).
Klee Foundation, Kunstmuseum, Bern.

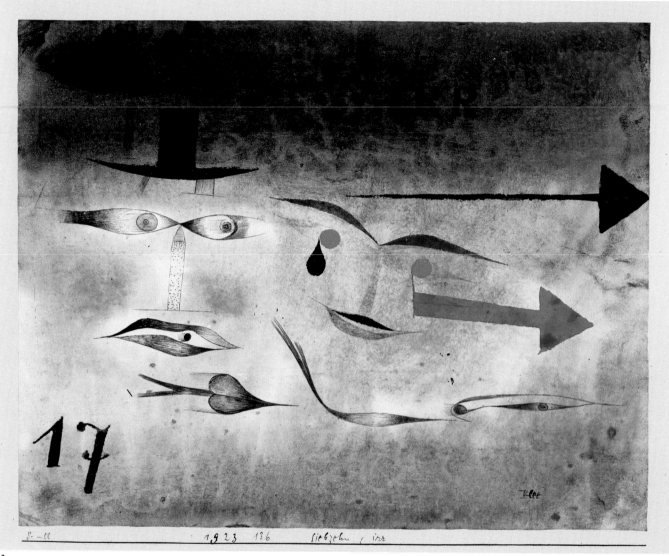

43

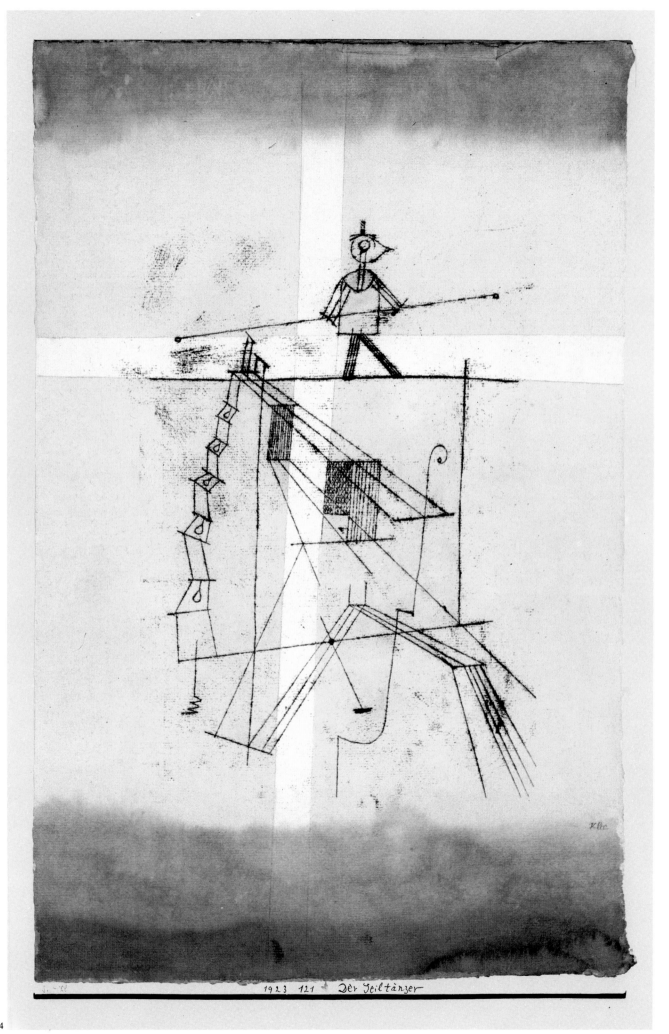

1923 121 Der Seiltänzer

45. *Harmony of Rectangles in Red, Yellow, Blue, White and Black*. 1923
(Harmonie aus Vierecken mit Rot, Gelb, Blau, Weiss und Schwarz)
Oil on cardboard,
27½ × 20 in. (69.7 × 50.6 cm).
Klee Foundation, Kunstmuseum, Bern.

46. *Cosmic Flora*. 1923.
(Kosmische Flora)
Watercolor and chalk background on paper mounted on cardboard,
10¾ × 14⅜ in. (27.2 × 36.6 cm).
Klee Foundation, Kunstmuseum, Bern.

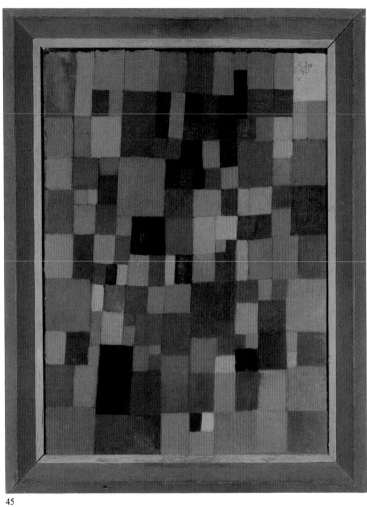

45

46

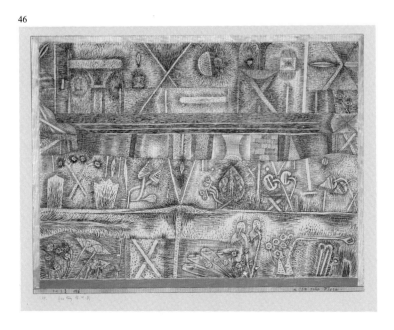

47. *Still Life with Props*. 1924.
 (Requisiten-Stilleben)
 Oil on muslin mounted on cardboard,
 $19 \times 18^{1/2}$ in. (48.5×47.1 cm).
 Klee Foundation, Kunstmuseum, Bern.

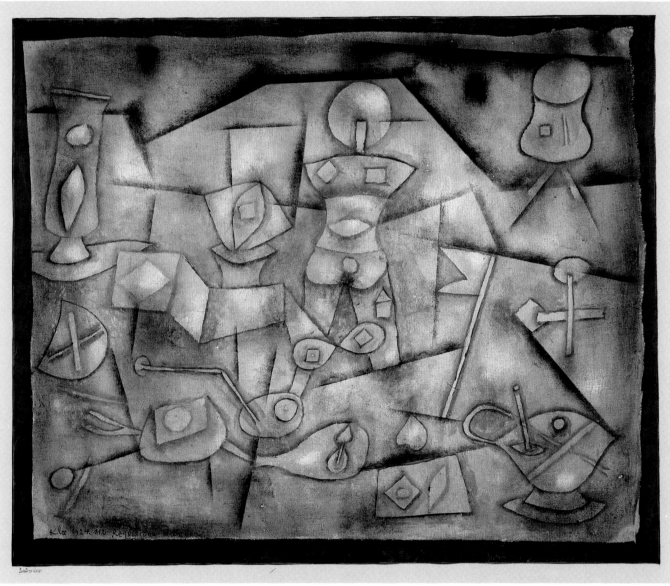

47

48. *Near Taormina. Scirocco.* 1924.
 (Bei Taormina. Scirocco)
 Watercolor and India ink on paper mounted on cardboard,
 6×9¼ in. (15.1×23.5 cm).
 Klee Foundation, Kunstmuseum, Bern.

49. *Carnival in the Mountains.* 1924.
 (Karneval im Gebirge)
 Watercolor on paper mounted on cardboard,
 10⅜×13 in. (26.5×33.1 cm).
 Klee Foundation, Kunstmuseum, Bern.

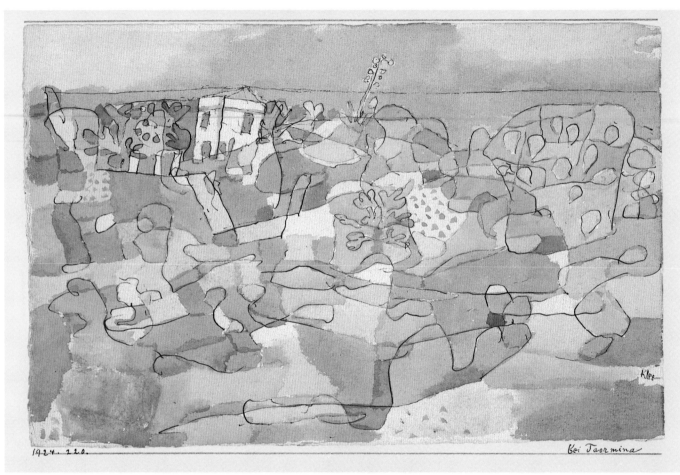

48

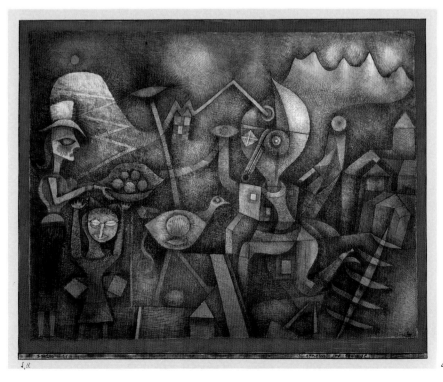

49

50. *Wall Picture*. 1924.
(Wandbild)
Watercolor on muslin and paper mounted on cardboard,
$10 \times 21^{5}/_{8}$ in. (25.4 × 55.1 cm).
Klee Foundation, Kunstmuseum, Bern.

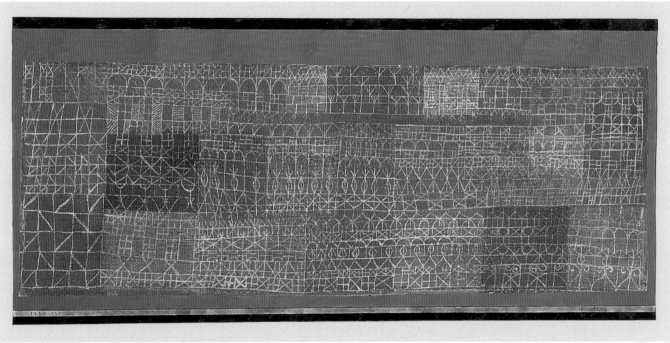

50

51. *Actor's Mask*. 1924.
(Schauspielermaske)
Oil on canvas, mounted on board,
14½ × 13⅜ in. (36.7 × 33.8 cm).
Collection, The Museum of Modern Art, New York.
The Sidney and Harriet Janis Collection.

52. *The Mask with the Little Flag*. 1925.
(Maske mit Fähnchen)
Watercolor on paper mounted on cardboard,
25½ × 19½ in. (65 × 49.5 cm).
Staatsgalerie, Munich.

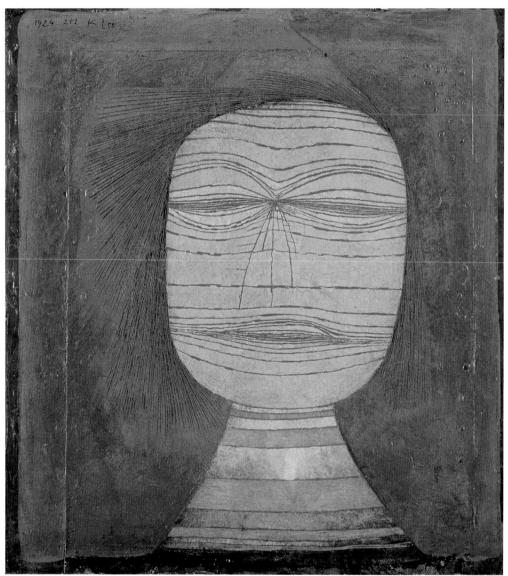

51

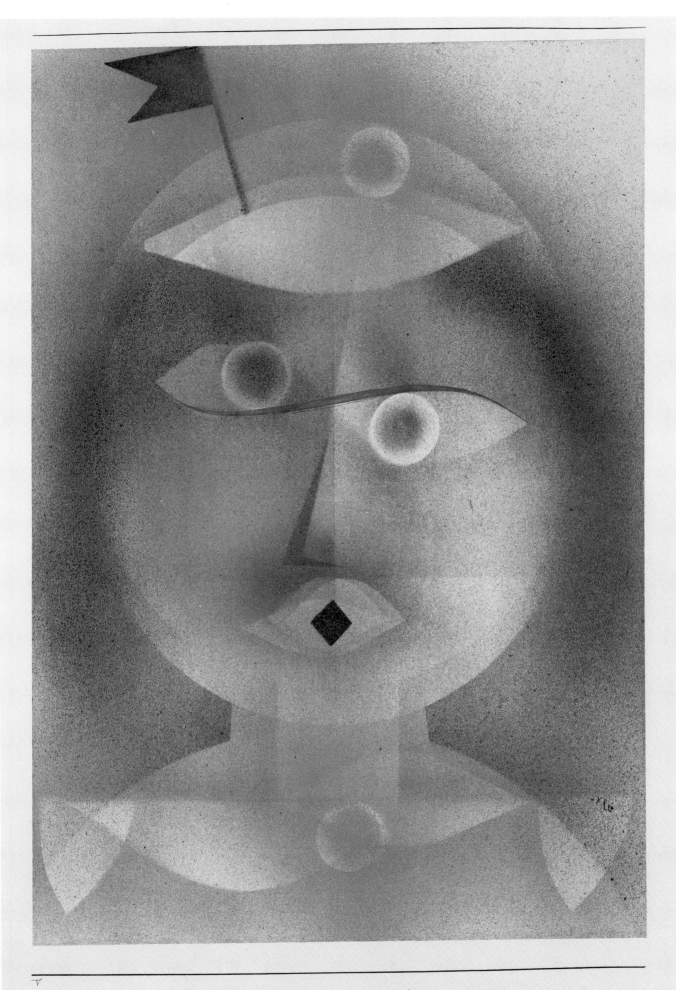

1925 W sill" die Maske mit dem Fähnchen

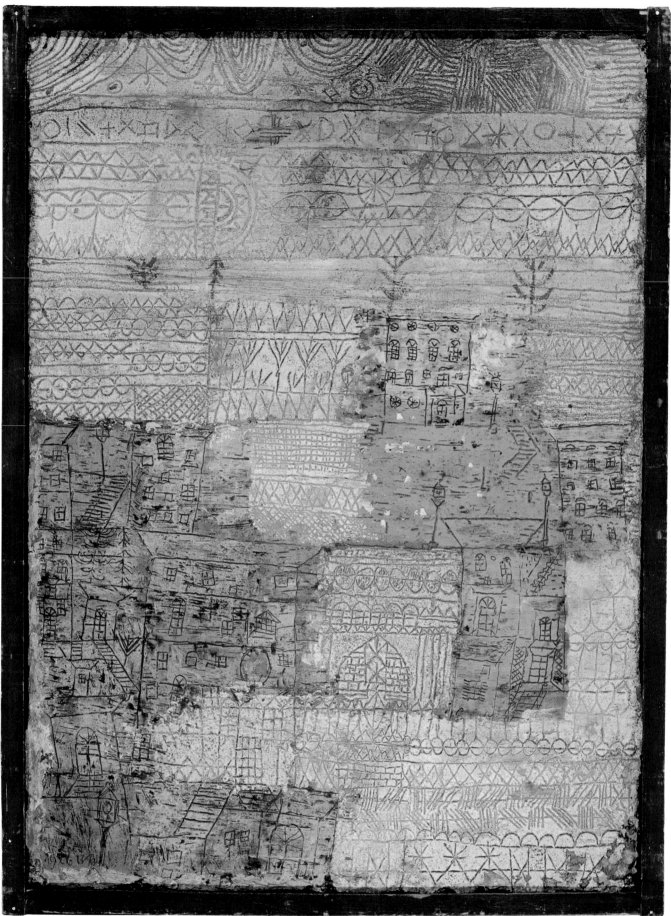

53. *Florentine Villa District*. 1926.
(Florentinische Villen)
Oil on canvas,
19½ × 14¾ in. (49.5 × 36.5 cm).
Musée National d'Art Moderne, Paris.

54. *Bird Wandering Off*. 1926.
(Auswandernder Vogel)
Gouache on canvas paper mounted on fine cardboard,
14¾ × 18⅝ in. (37.5 × 47.3 cm).
The Metropolitan Museum of Art, New York.
The Berggruen Klee Collection.

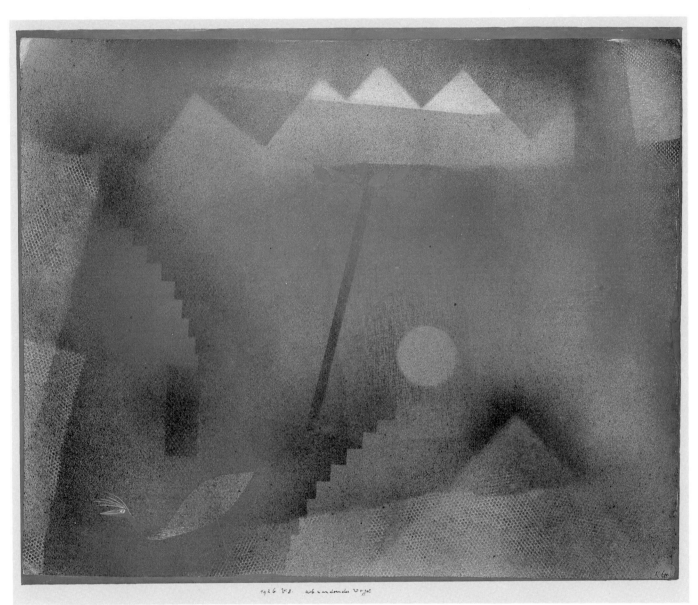

54

55. *Fish People.* 1927.
(Fisch-Leute)
Oil and tempera on plastered canvas and cardboard mounted on board,
12⅝ × 21⅝ in. (32.1 × 55 cm).
Klee Foundation, Kunstmuseum, Bern.

56. *She is Sinking into the Grave!* 1926.
(Sie sinkt ins Grab!)
Watercolor and India ink on paper mounted on cardboard,
19 × 13½ in. (48.5 × 34.4 cm).
Klee Foundation, Kunstmuseum, Bern.

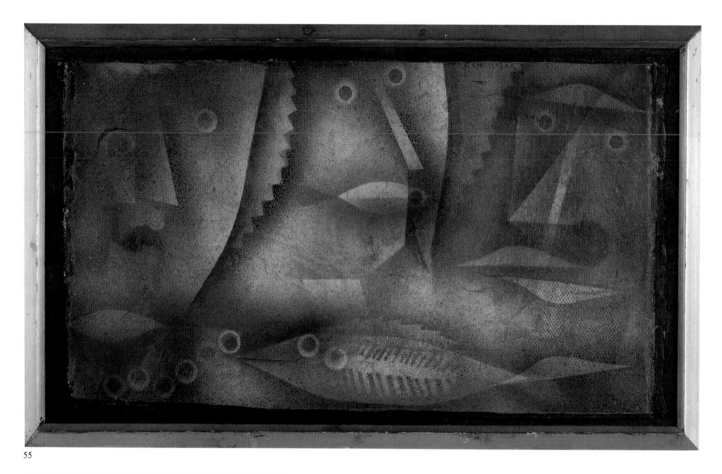

55

56

57. *Portrait of an Acrobat.* 1927.
(Artistenbildnis)
Oil and collage on cardboard over wood with painted plaster border,
24⅞ × 15¾ in. (63.2 × 40 cm).
Collection, The Museum of Modern Art, New York.
Mrs. Simon Guggenheim Fund.

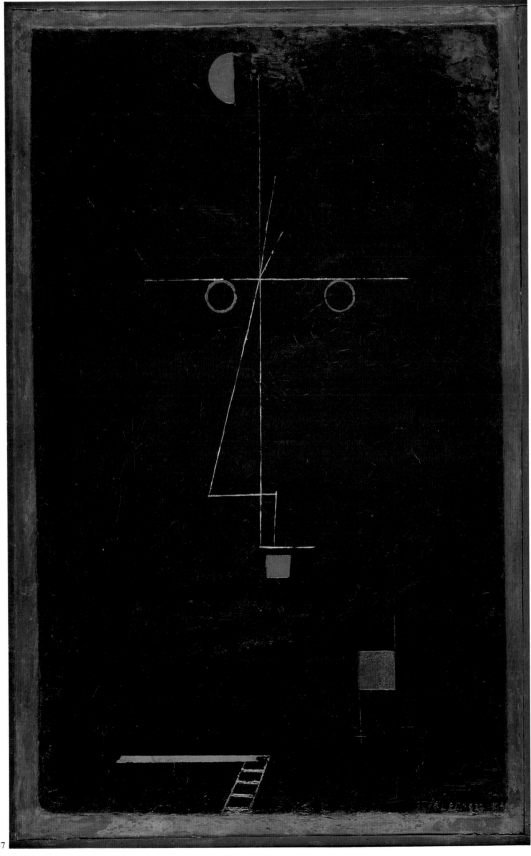

58. *Sailing-Ships*. 1927.
(Segelschiffe)
Watercolor on paper mounted on cardboard,
9 × 11⅞ in. (22.8 × 30.2 cm).
Klee Foundation, Kunstmuseum, Bern.

59. *Variations (Progressive Motif)*. 1927.
(Variationen-Progressives Motiv)
Oil and watercolor on canvas,
16 × 15½ in. (40.6 × 39.4 cm).
The Metropolitan Museum of Art, New York.
The Berggruen Klee Collection.

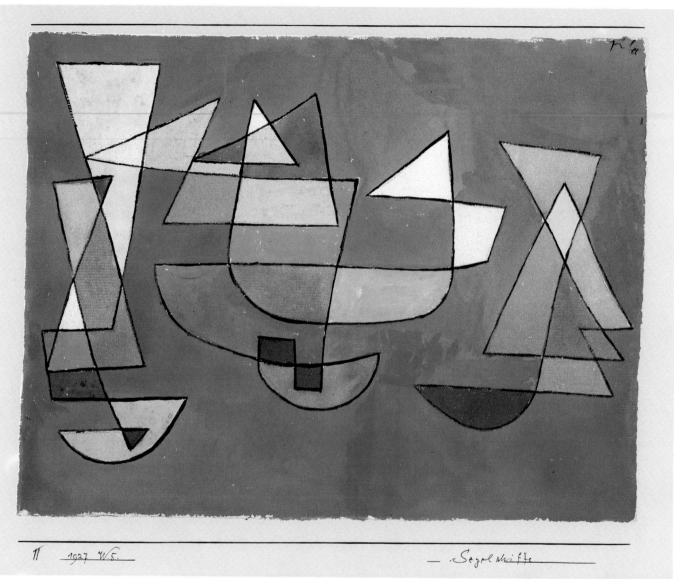

58

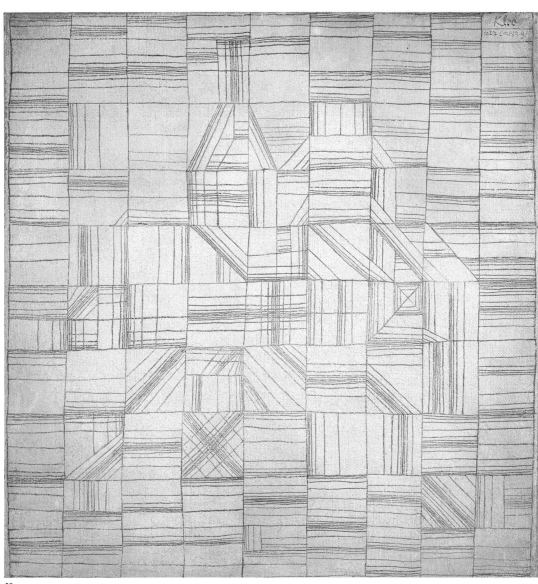

59

60. *She Bellows, We Play*. 1928.
 (Sie brüllt, wir spielen)
 Oil on canvas,
 17⅛ × 22¼ in. (43.5 × 56.5 cm).
 Klee Foundation, Kunstmuseum, Bern.

61. *Cat and Bird*. 1928.
 (Katze und Vogel)
 Oil and ink on gessoed canvas, mounted on wood,
 15 × 21 in. (38.1 × 53.2 cm).
 Collection, The Museum of Modern Art, New York.
 Sidney and Harriet Janis Collection Fund and gift of
 Suzy Prudden and Loan H. Meijer in memory of F. H. Hirschland.

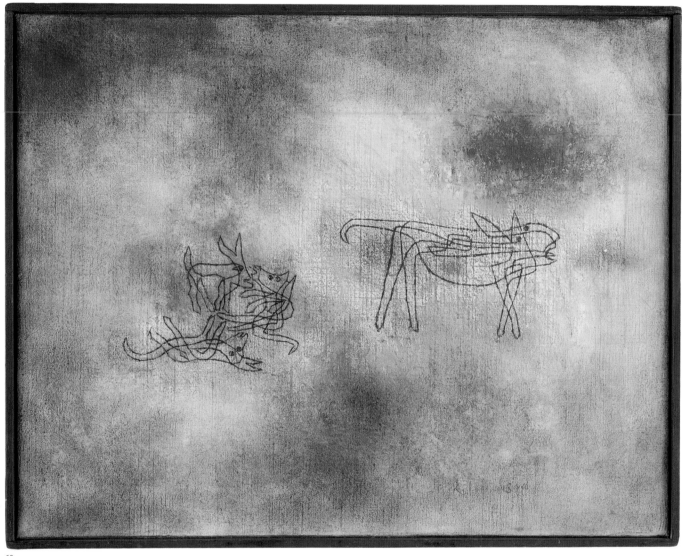

60

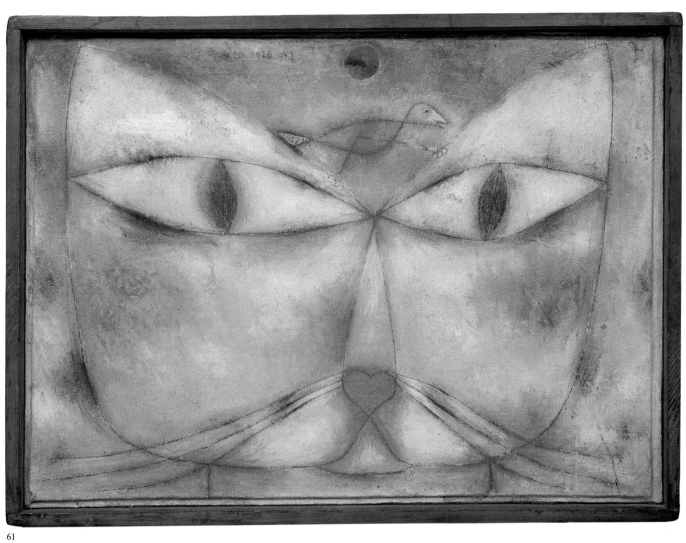

61

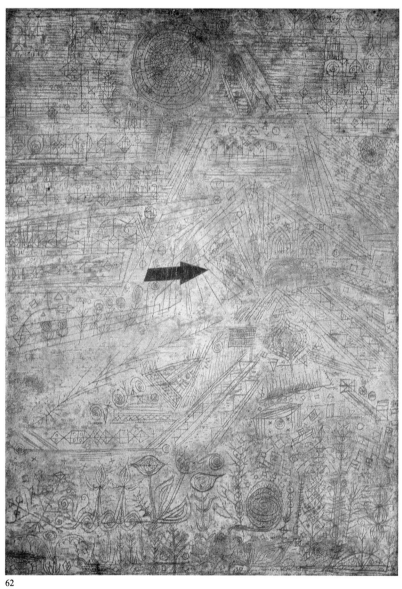

62

62. *Arrow in the Garden*. 1929.
(Pfeil in einem Garten)
Oil on canvas,
27½ × 19⅝ in. (70 × 50 cm).
Musée National d'Art Moderne, Paris.

63. *Highroad and Byroads*. 1929.
(Hauptweg und Nebenwege)
Oil on canvas,
33 × 26½ in. (83.7 × 67.5 cm).
Museum Ludwig, Cologne.

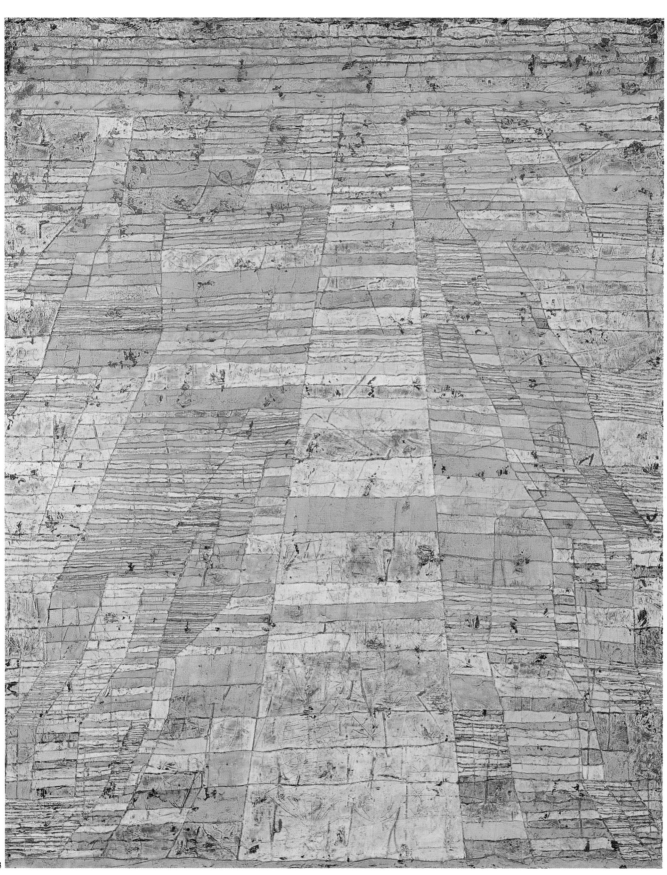

63

64. *Dispute*. 1929.
(Disput)
Oil on canvas,
$26\frac{3}{8} \times 26\frac{3}{8}$ in. (67×67 cm).
Klee Foundation, Kunstmuseum, Bern.

65. *Monument in Fertile Country*. 1929.
(Monument im Fruchtland)
Watercolor on paper mounted on cardboard,
$18 \times 12\frac{1}{8}$ in. (45.7×30.8 cm).
Klee Foundation, Kunstmuseum, Bern.

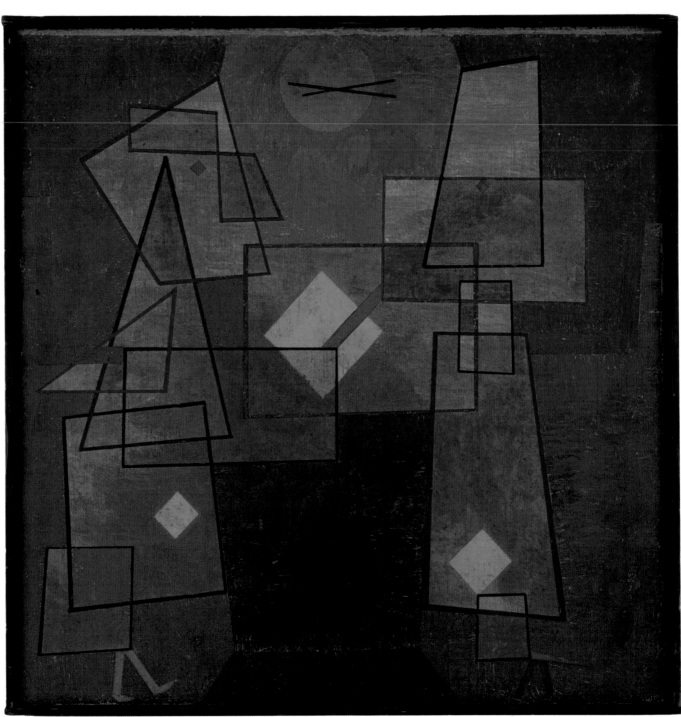

64

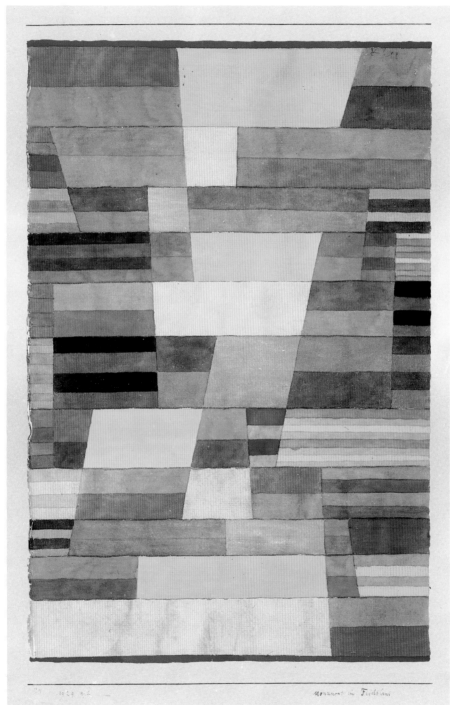

Monument in Fruchtland

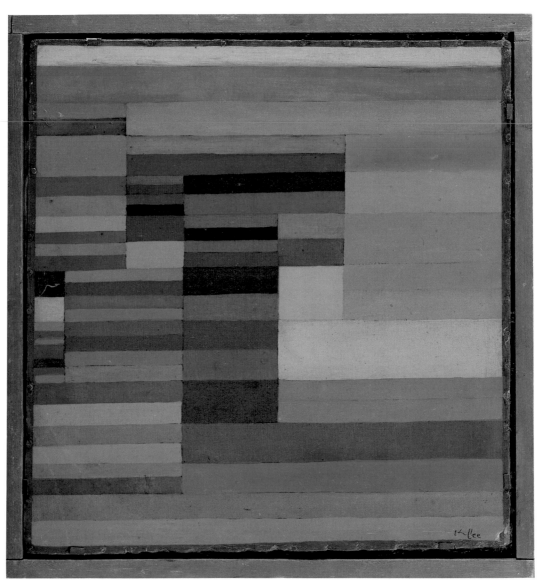

66

66. *Fire in Evening*. 1929.
 (Feuer Abends)
 Oil on cardboard,
 13³/₈ × 13¹/₄ in. (33.8 × 33.4 cm).
 Collection, The Museum of Modern Art, New York.
 Mr. and Mrs. Joachim Jean Aberbach Fund.

67. *Color Table (on Major Grey)*. 1930.
 (Farbtafel - auf maiorem Grau)
 Pastel on cardboard,
 14⁷/₈ × 12 in. (37.7 × 30.4 cm).
 Klee Foundation, Kunstmuseum, Bern.

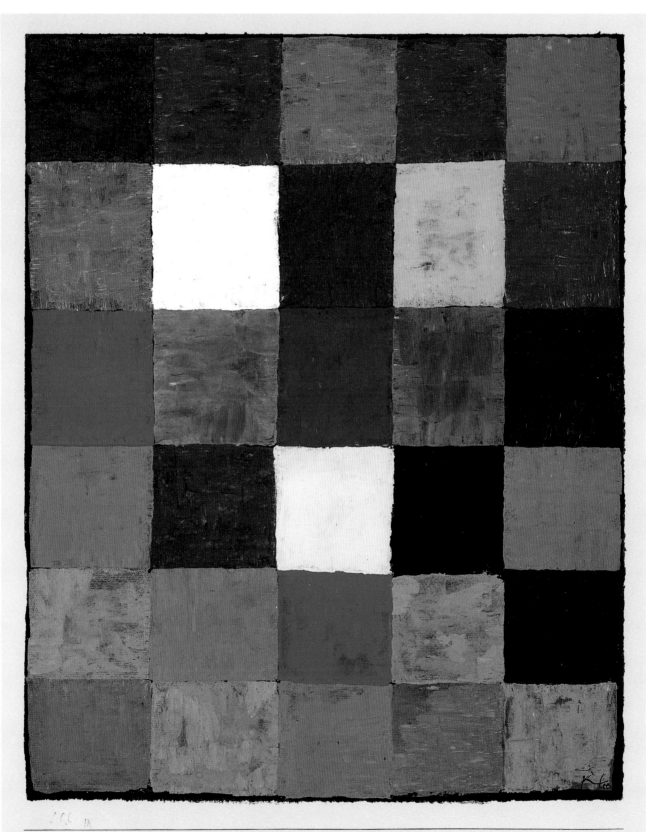

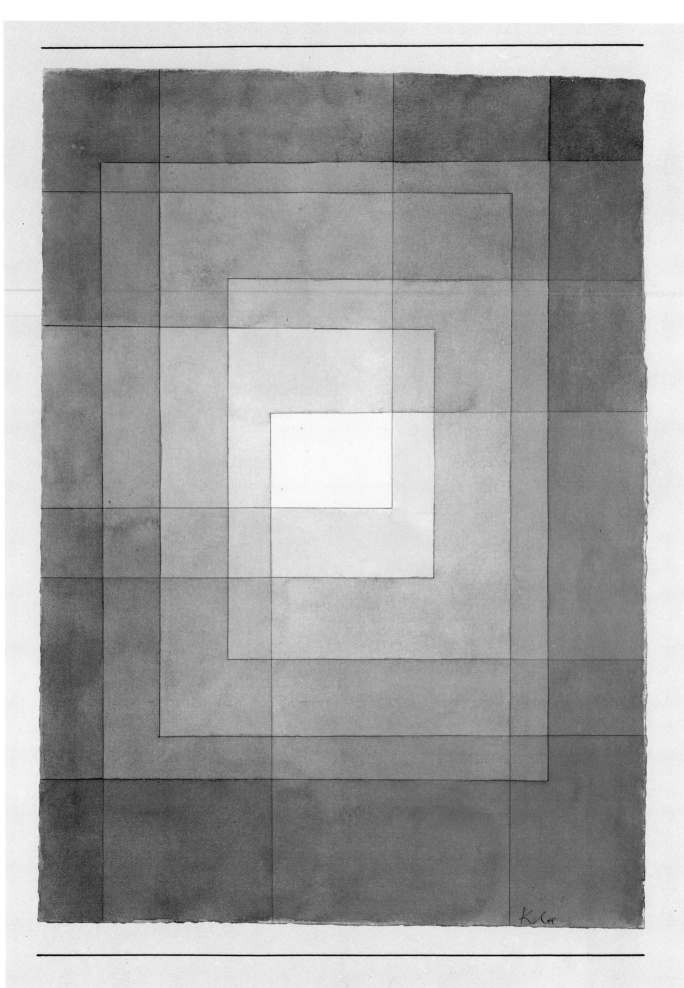

1930 X 18 · polyphon gefasstes Weiss

68. *Polyphonically Enclosed White*. 1930.
(Polyphongafasstes Weiss)
Watercolor and India ink on paper mounted on cardboard,
13⅛ × 9⅝ in. (33.3 × 24.5 cm).
Klee Foundation, Kunstmuseum, Bern.

69. *Open Book*. 1930.
(Aufgeschlagenes Buch)
Gouache and white lacquer on canvas,
17½ × 16⅜ in. (44.7 × 41.5 cm).
The Solomon R. Guggenheim Museum, New York.

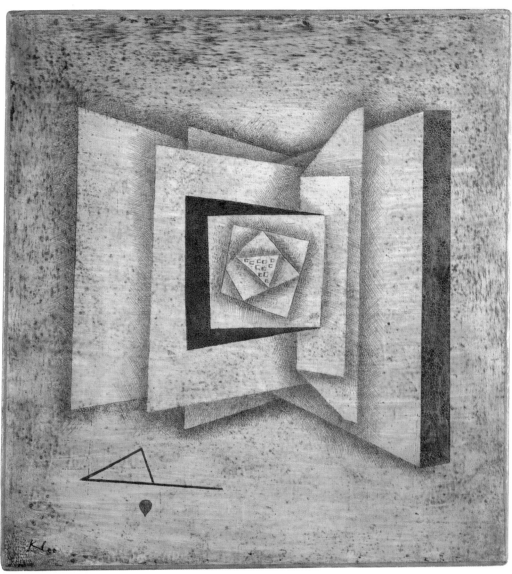

69

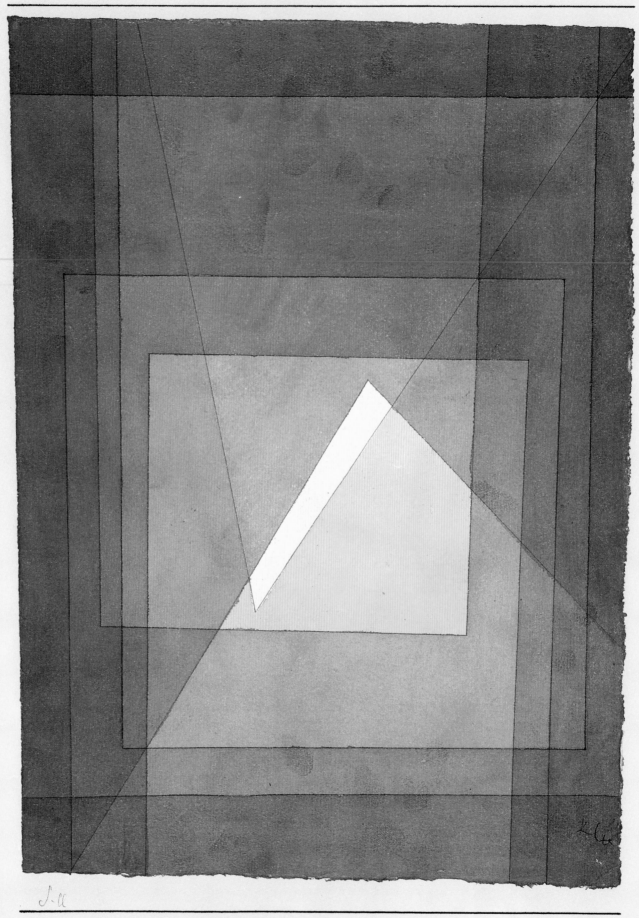

1930 H.8. Pyramide

70. *Pyramid*. 1930.
 (Pyramide)
 Watercolor and India ink on paper mounted on cardboard,
 12¼ × 9⅛ in. (31.2 × 23.2 cm).
 Klee Foundation, Kunstmuseum, Bern.

71. *Phantoms' Oath*. 1930.
 (Gespenster-Schwur)
 Watercolor and red chalk on paper mounted on cardboard,
 18½ × 14⅞ in. (47.1 × 37.8 cm).
 Klee Foundation, Kunstmuseum, Bern.

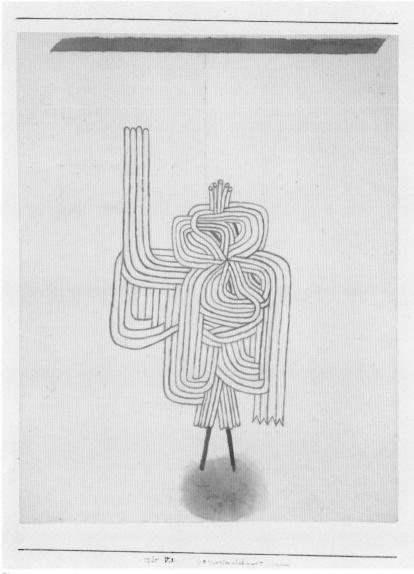

71

72. *Ad Marginem*. 1930.
 (Ad Marginem)
 Watercolor and India ink on plastered gauze mounted on cardboard,
 17⅛ × 13 in. (43.5 × 33 cm).
 Öffentliche Kunstsammlung Basel, Kunstmuseum.

73. *Ad Parnassum*. 1932.
 (Ad Parnassum)
 Oil on canvas,
 39⅜ × 49½ in. (100 × 126 cm).
 Klee Foundation, Kunstmuseum, Bern.

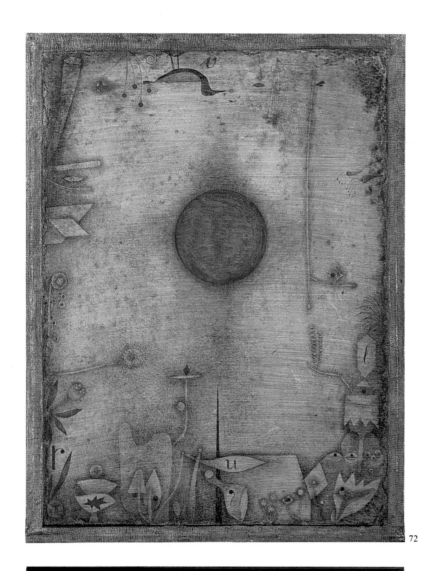

72

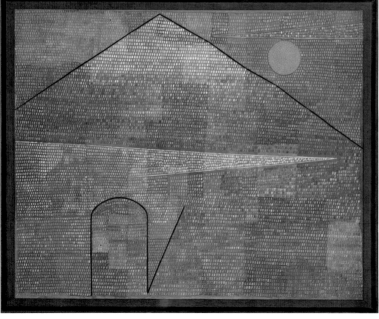

73

74. *Castle Garden*. 1931.
(Schlossgarten)
Oil on canvas,
26½ × 21⅝ in. (67.2 × 54.9 cm).
Collection, The Museum of Modern Art, New York.
Sidney and Harriet Janis Collection Fund.

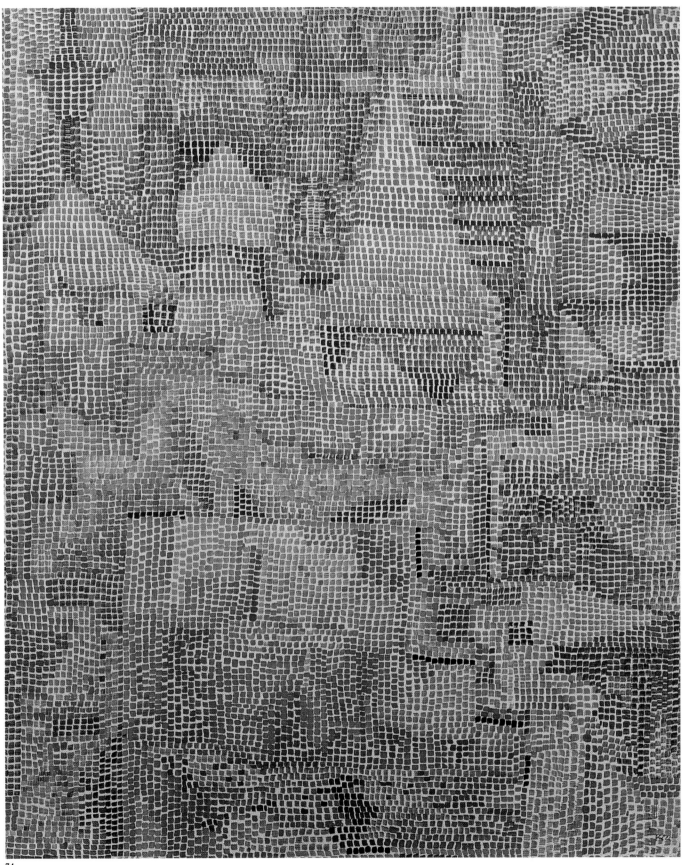

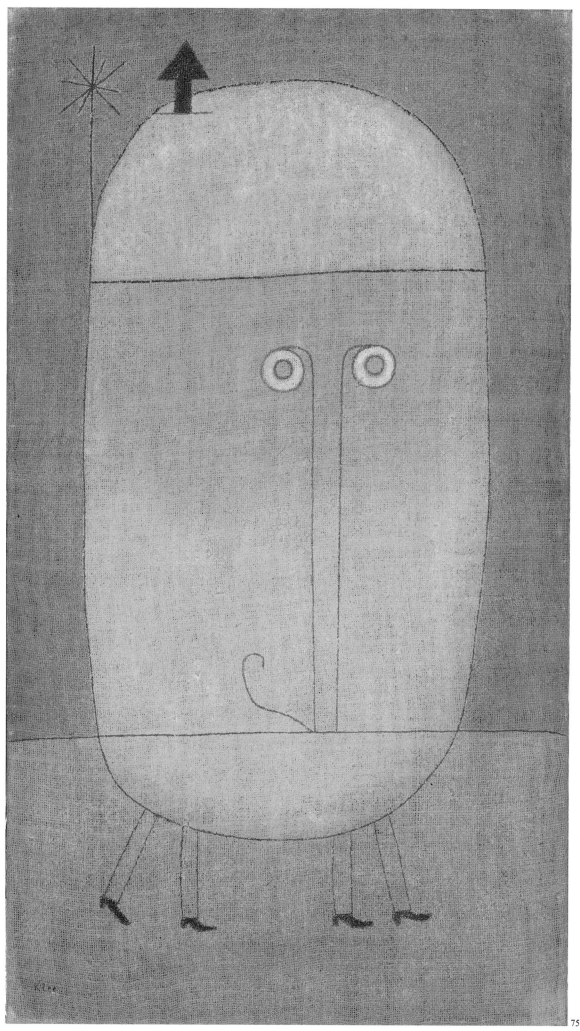

75. *Mask of Fear*. 1932.
(Maske Furcht)
Oil on burlap,
39½ × 22½ in. (100.4 × 57.1 cm).
Collection, The Museum of Modern Art, New York.
Nelson A. Rockefeller Fund.

76. *North Room*. 1932.
(Nordzimmer)
Watercolor on paper mounted on cardboard,
14½ × 21⅝ in. (37 × 55 cm).
Klee Foundation, Kunstmuseum, Bern.

77. *Polyphony*. 1932.
(Polyphonie)
Oil on canvas,
41¾ × 26⅛ in. (106 × 66.5 cm).
Emanuel Hoffmann Foundation, Kunstmuseum Basel.

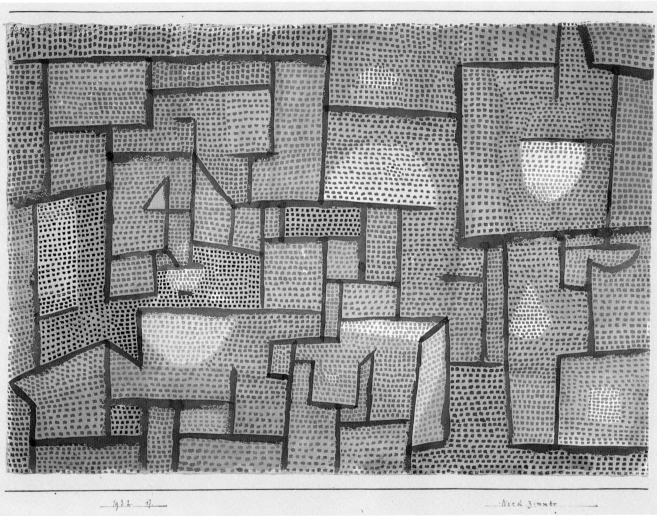

76

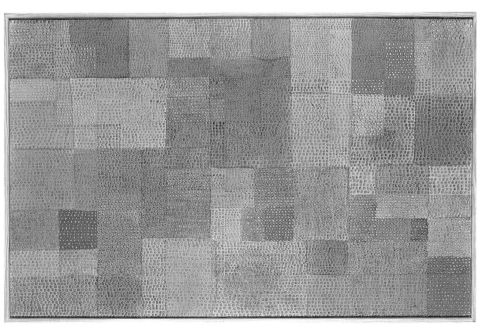

77

78. *Small Town among the Rocks*. 1932.
 (Kleine Felsenstadt)
 Oil on canvas,
 17½ × 22¼ in. (44.5 × 56.5 cm).
 Klee Foundation, Kunstmuseum, Bern.

79. *Twilight in the Park*. 1932.
 (Dämmerung im Park)
 Watercolor and black drawing on plastered canvas mounted on cardboard,
 13½ × 24⅜ in. (34.4 × 62 cm).
 Klee Foundation, Kunstmuseum, Bern.

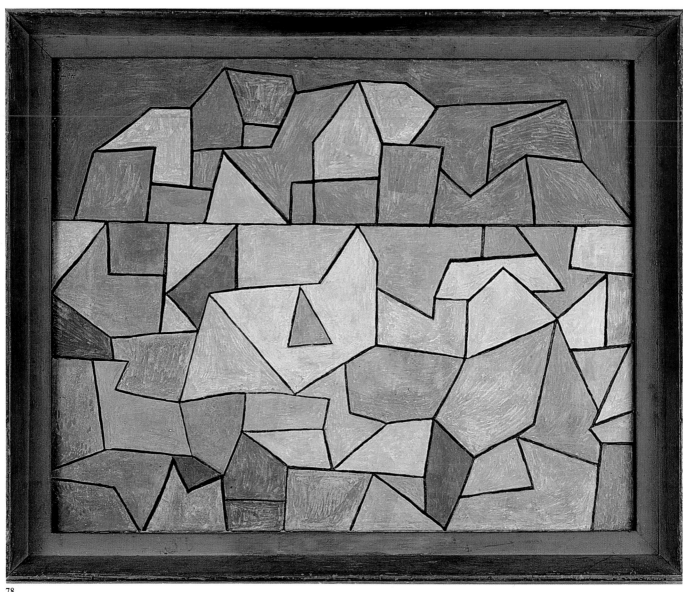

78

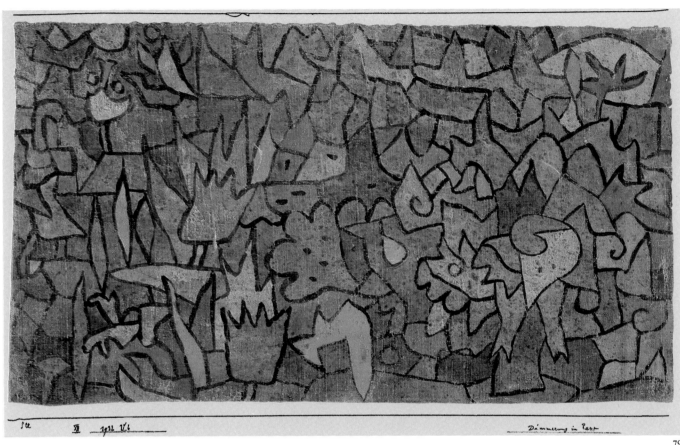

ce　Ⅻ　*1938 V.6*　　　　　　　　　　　　　　　　　　　*Dämmerung in Park*

80. *Sphinx Resting.* 1934.
(Ruhende Sphinx)
Oil on canvas,
35½ × 47¼ in. (90 × 120 cm).
Klee Foundation, Kunstmuseum, Bern.

81. *Seasnail King.* 1933.
(Meerschnecken-König)
Oil on canvas,
71½ × 22¼ in. (44.5 × 56.5 cm).
Klee Foundation, Kunstmuseum, Bern.

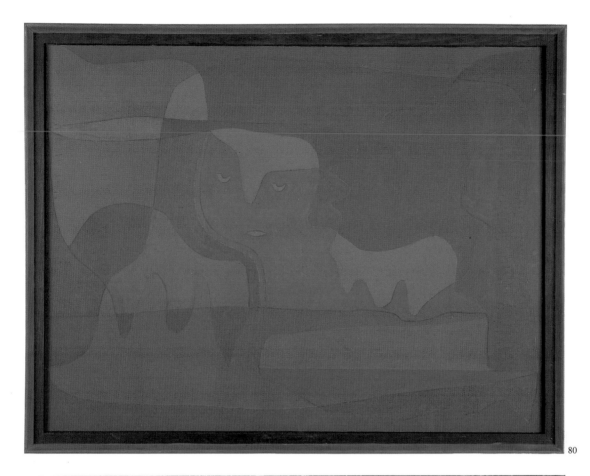

80

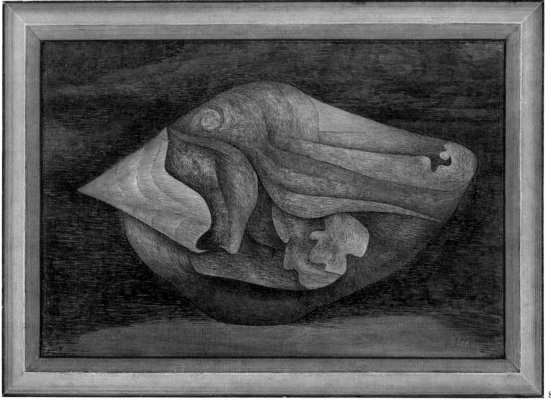

81

82. *The Creator*. 1934.
(Der Schöpfer)
Oil on canvas,
16½ × 21 in. (42 × 53.5 cm).
Klee Foundation, Kunstmuseum, Bern.

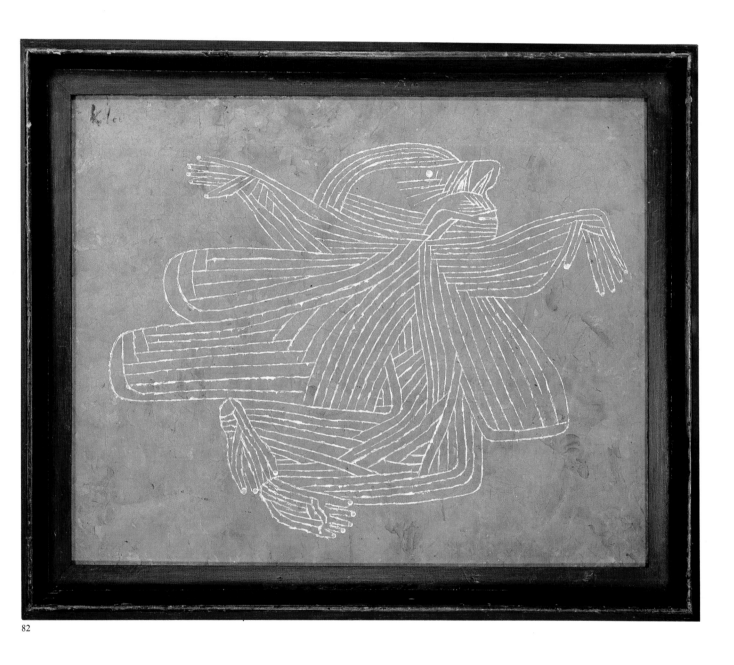

82

83. *Blossoming*. 1934.
(Blühendes)
Oil on canvas,
$31^{7}/_{8} \times 31^{1}/_{2}$ in. (81×80 cm).
Kunstmuseum, Winterthur.

84. *Dame Demon*. 1935.
(Dame Dämon)
Oil and watercolor on plastered burlap mounted on cardboard,
$59^{1}/_{4} \times 39^{3}/_{8}$ in. (150.5×100 cm).
Klee Foundation, Kunstmuseum, Bern.

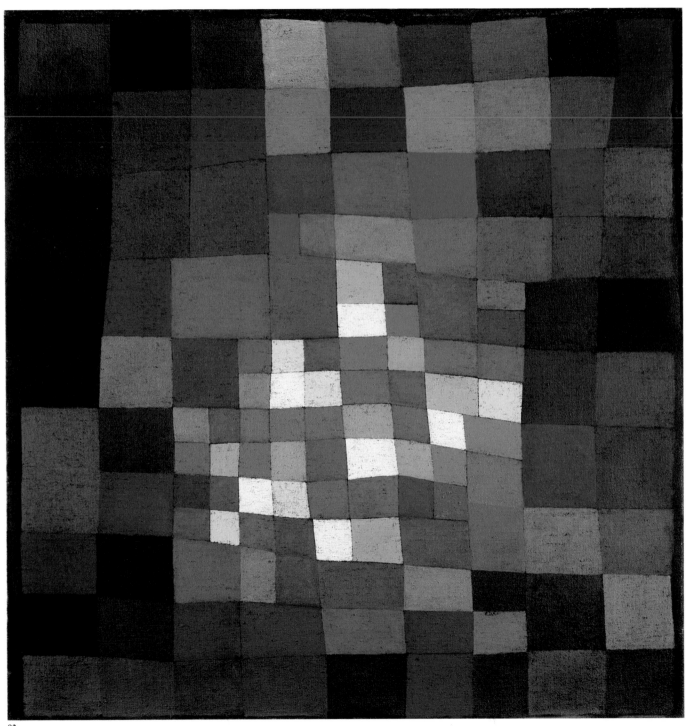

83

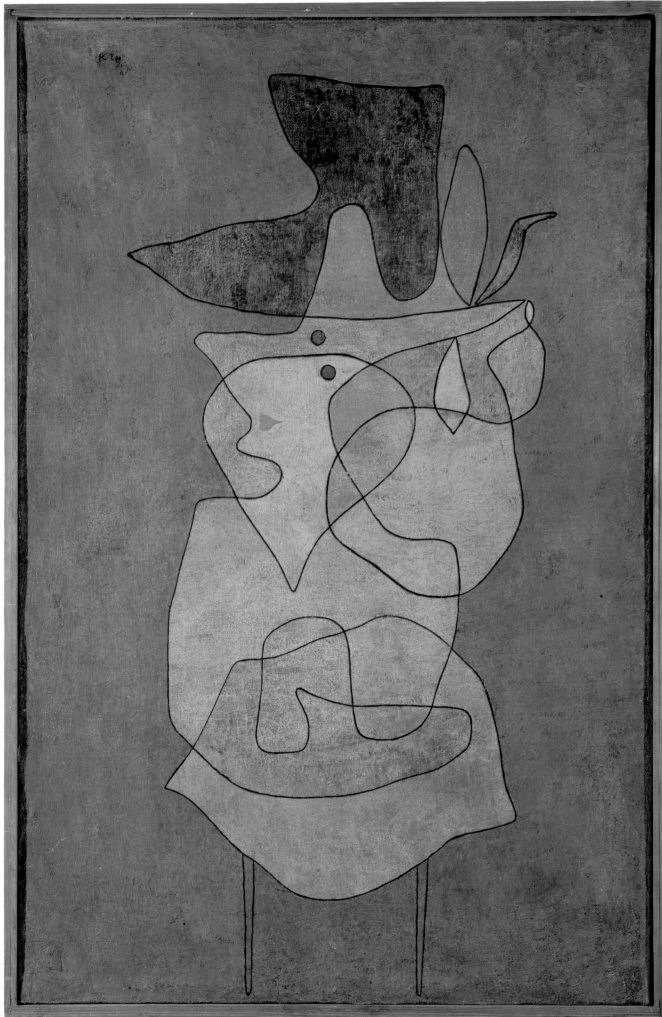

84

85. *Planting According to Rules*. 1935.
(Nach Regeln zu Pflanzen)
Watercolor on paper mounted on cardboard,
10⅛ × 14½ in. (25.8 × 36.9 cm).
Kunstmuseum, Bern. Hermann and Margrit Rupf Foundation.

86. *Light and Sharp Edges*. 1935.
(Das Licht und die Schärfen)
Watercolor on paper mounted on cardboard,
12½ × 18⅞ in. (32 × 48 cm).
Klee Foundation, Kunstmuseum, Bern.

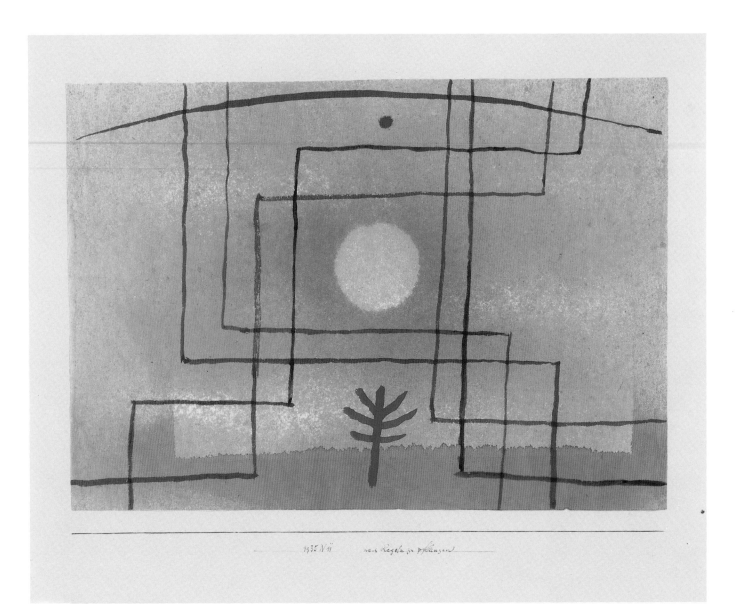

85

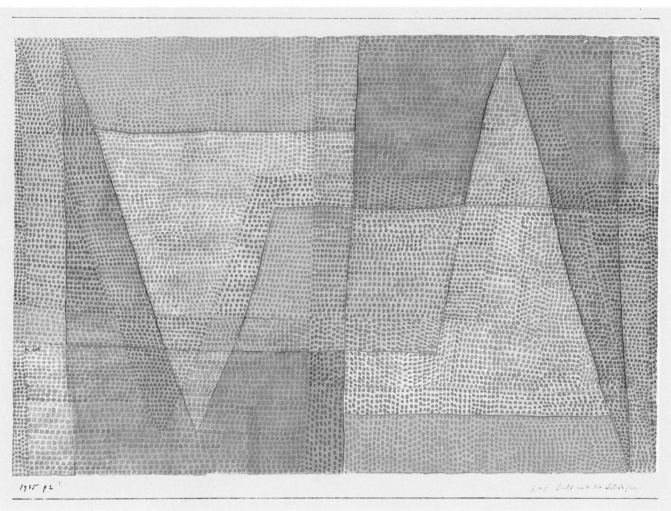

1935 p2 Das Bild mit den Schätzen

86

87. *Flower Garden in the Park of V*. 1936.
 (Blumenanlage im Park von V.)
 Pastel on cotton cloth mounted on cardboard,
 20 × 18⅜ in. (30.3 × 46.6 cm).
 Klee Foundation, Kunstmuseum, Bern.

88. *New Harmony*. 1936.
 (Neue Harmonie)
 Oil on canvas,
 37 × 26 in. (94 × 66 cm).
 The Solomon R. Guggenheim Museum, New York.

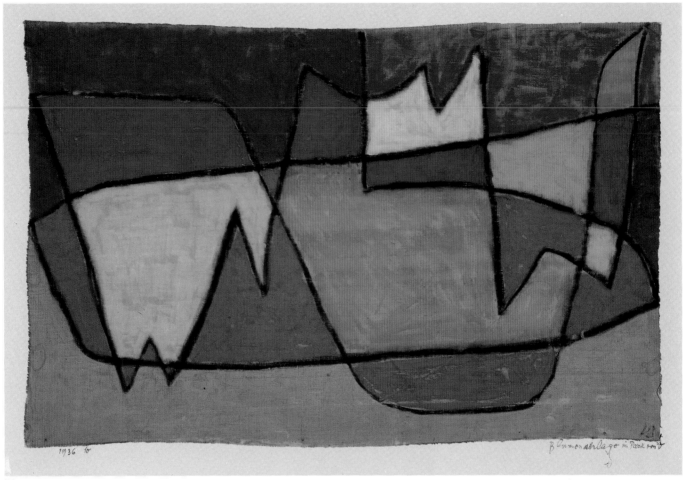

87

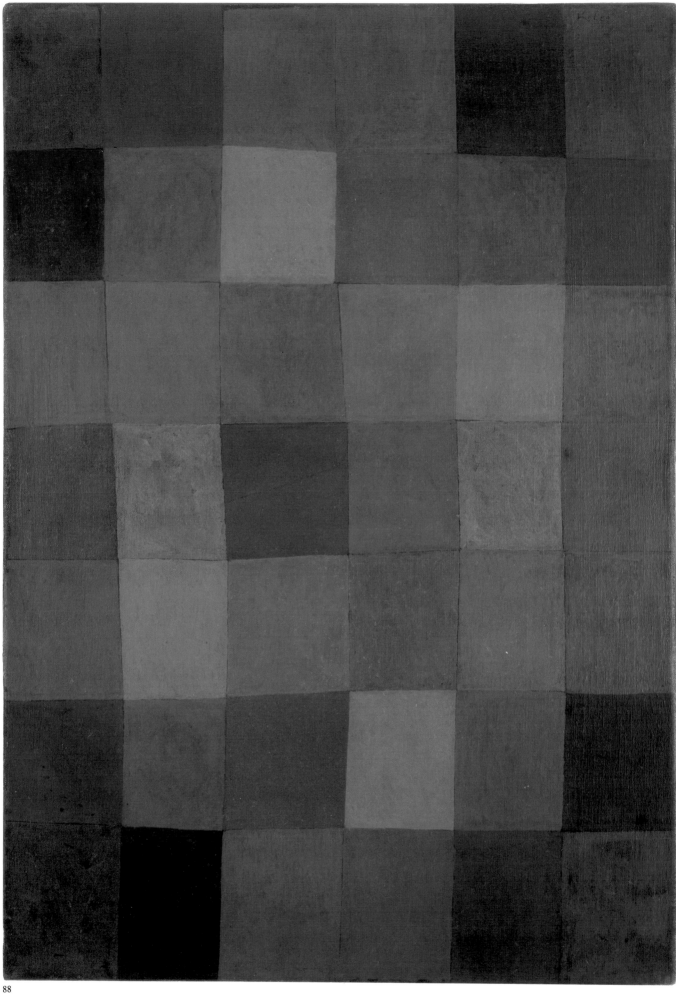

89. *Harbor with Sailboats*. 1937.
 (Hafen und Segelboote)
 Oil on canvas,
 31½ × 23⅝ in. (80 × 60 cm).
 Musée National d'Art Moderne, Paris.

90. *Blue Night*. 1937.
 (Blaue Nacht)
 Gouache on cotton cloth mounted on burlap,
 19¾ × 30 in. (50.3 × 76.4 cm).
 Öffentliche Kunstsammlung, Basel.

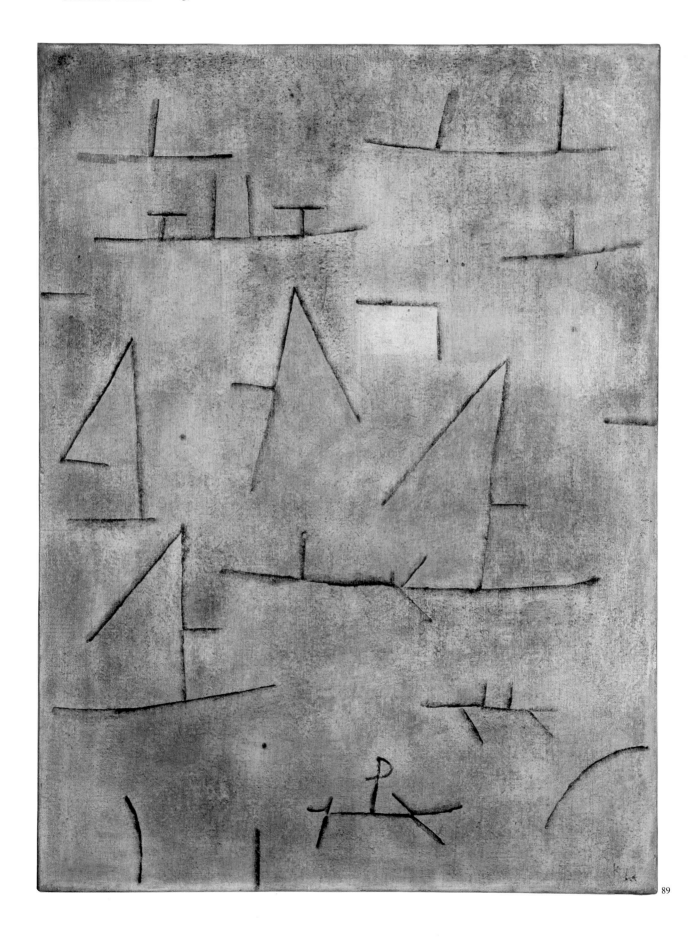

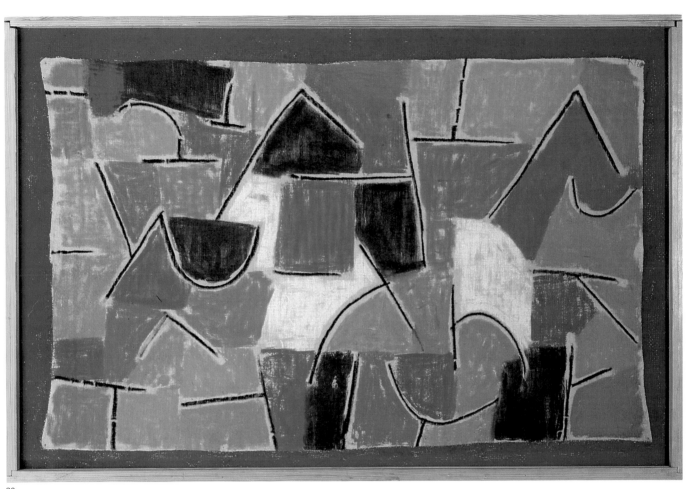

90

91. *Legend of the Nile*. 1937.
(Legende vom Nil)
Pastel on cotton cloth mounted on burlap,
27$\frac{1}{8}$ × 24 in. (69 × 61 cm).
Kunstmuseum, Bern. Hermann and Margrit Rupf Foundation.

92. *Harmonized Battle*. 1937.
(Harmonisierter Kampf)
Pastel on cotton cloth mounted on burlap,
22$\frac{1}{2}$ × 33$\frac{7}{8}$ in. (57 × 86 cm).
Klee Foundation, Kunstmuseum, Bern.

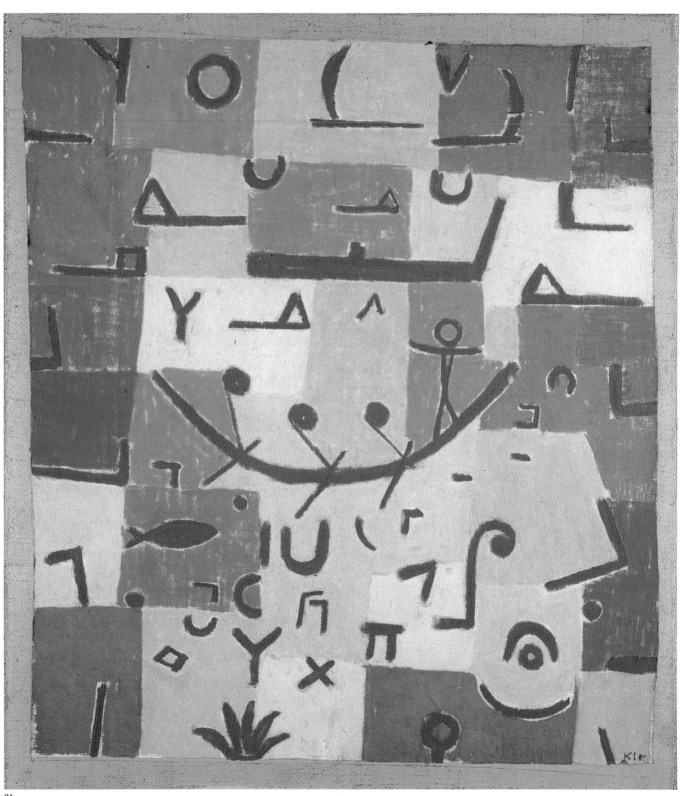

91

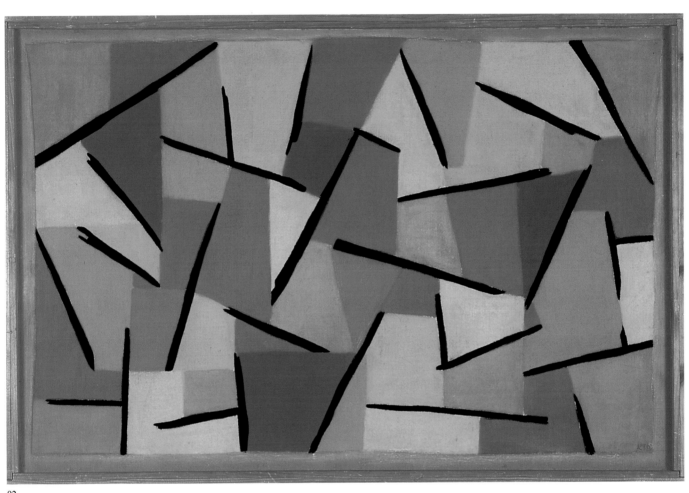

92

93. *Stage Landscape*. 1937.
(Bühnen-Landschaft)
Pastel on cotton cloth mounted on burlap,
23 × 33⅞ in. (58.5 × 86 cm).
Kunstmuseum Berna. Hermann and Margrit Rupf Foundation.

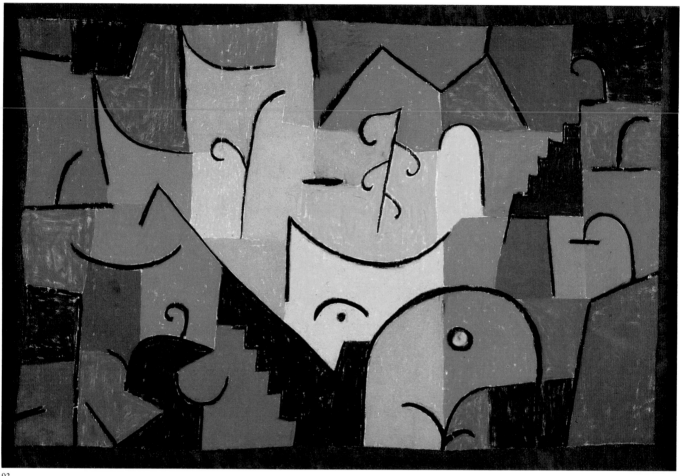

93

94. *Flora*. 1937.
 (Flora)
 Oil on paper mounted on cardboard,
 15½ × 11⅜ in. (39.4 × 28.9 cm).
 Klee Foundation, Kunstmuseum, Bern.

95. *A Glance Out of Egypt*. 1937.
 (Ein Blick aus Aegypten)
 Pastel on paper mounted on cardboard,
 10⅞ × 6½ in. (27.6 × 16.3 cm).
 Klee Foundation, Kunstmuseum, Bern.

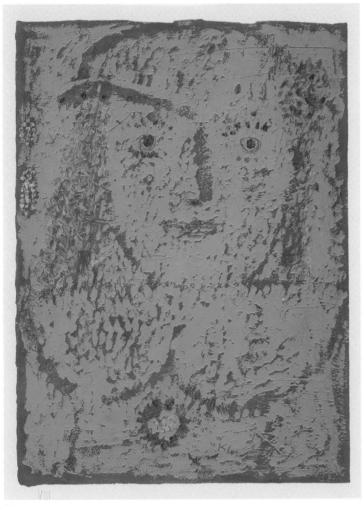

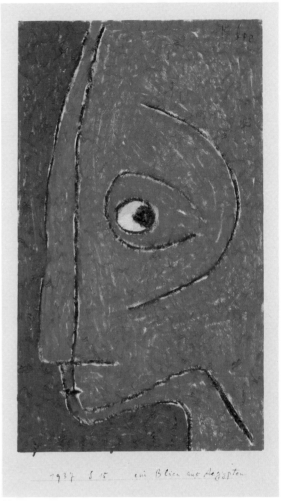

94 95

96. *Aeolian*. 1938.
 (Aeolisches)
 Oil on newspaper mounted on burlap,
 20½ × 26¾ in. (52 × 68 cm).
 Kunstmuseum, Berna, Hermann and Margrit Rupf Foundation.

97. *Heroic Strokes of the Bow*. 1938.
 (Heroische Bongenstriche)
 Colored paste on newspaper on dyed cotton fabric,
 28¾ × 20⅞ in. (73 × 52.7 cm).
 Collection, The Museum of Modern Art, New York.
 Nelson A. Rockefeller Bequest.

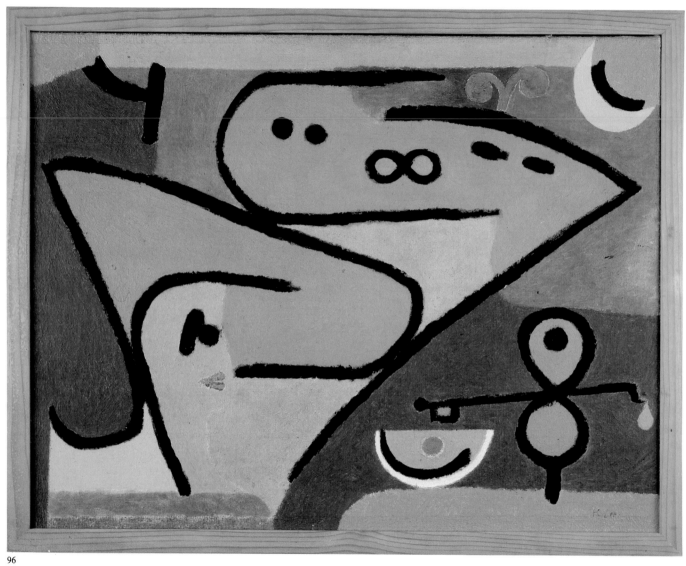

96

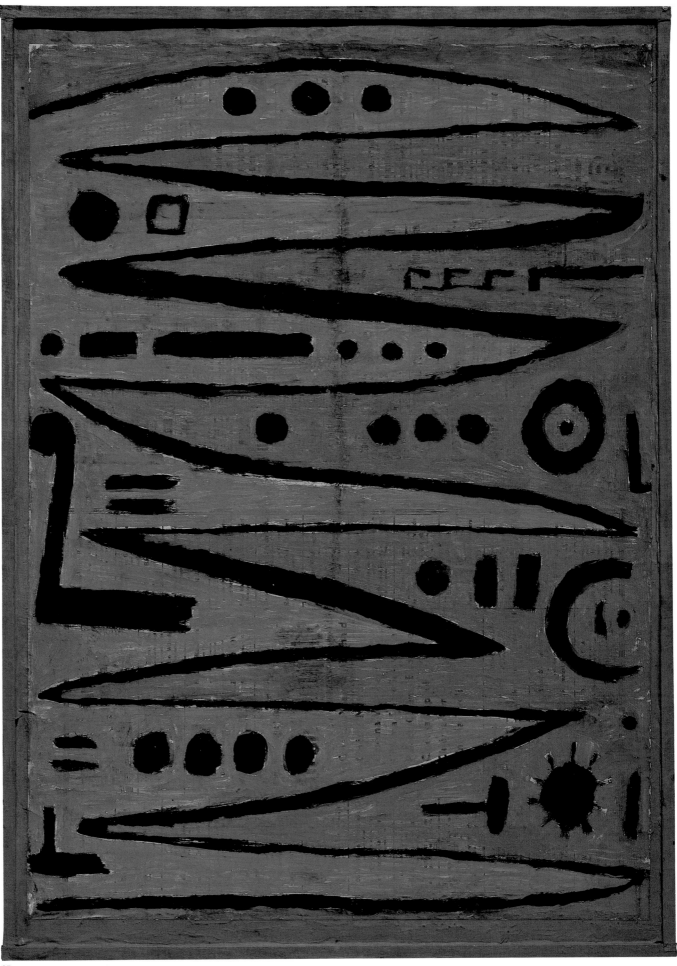

97

98. *Coelin Fruit*. 1938.
(Coelin-Frucht)
Colored paste on paper mounted on cardboard,
14 × 10½ in. (35.4 × 26.6 cm).
Klee Foundation, Kunstmuseum, Bern.

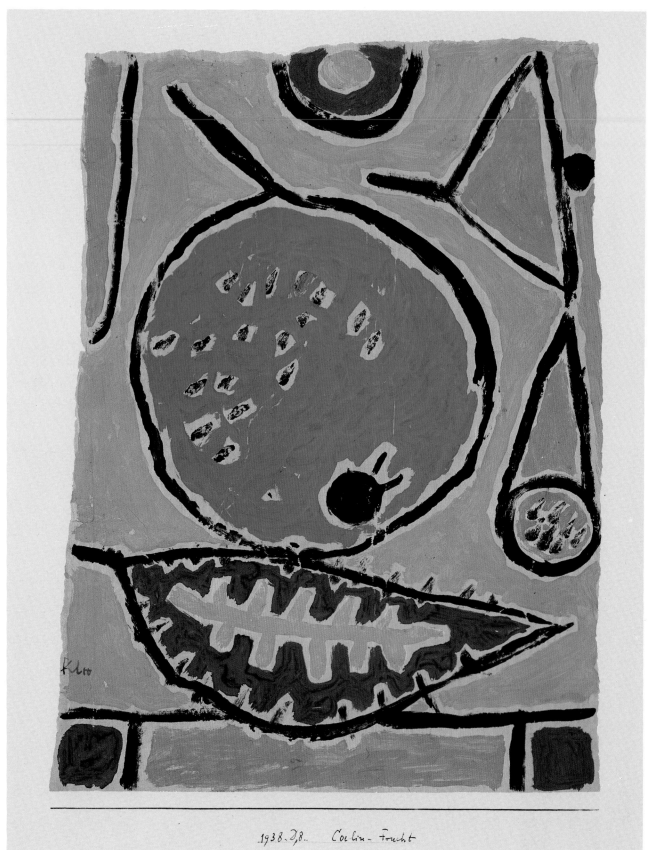

99. *Three Young Exotics*. 1938.
 (Drei junge Exoten)
 Colored paste on paper mounted on cardboard,
 18⅜ × 15⅝ in. (46.6 × 39.8 cm).
 Klee Foundation, Kunstmuseum, Bern.

100. *Early Sorrow*. 1938.
 (Frühes Leid)
 Oil and watercolor on plastered burlap mounted on cardboard,
 13⅝ × 17¾ in. (34.4 × 45 cm).
 Klee Foundation, Kunstmuseum, Bern.

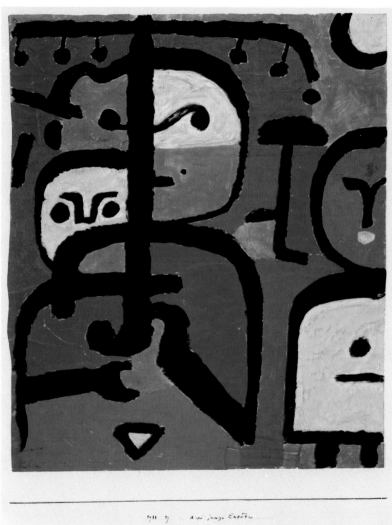

99

100

101. *Rich Harbor*. 1938.
 (Reicher Hafen)
 Tempera on paper mounted on canvas,
 $29^{3}/_{4} \times 65$ in. (75.5×165 cm).
 Öffentliche Kunstsammlung Basel, Kunstmuseum.

102. *Intention*. 1938.
 (Vorhaben)
 Colored paste on newspaper mounted on burlap,
 $29^{1}/_{2} \times 44$ in. (75×112 cm).
 Klee Foundation, Kunstmuseum, Bern.

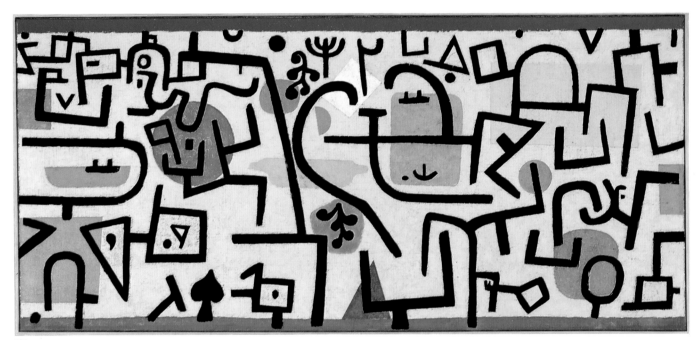

101

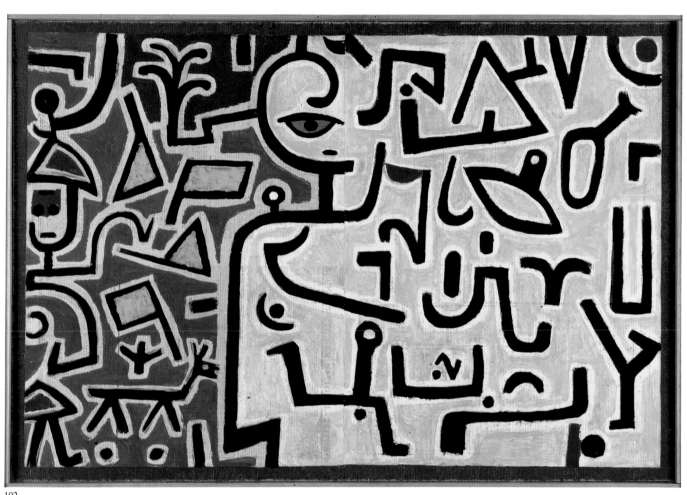

102

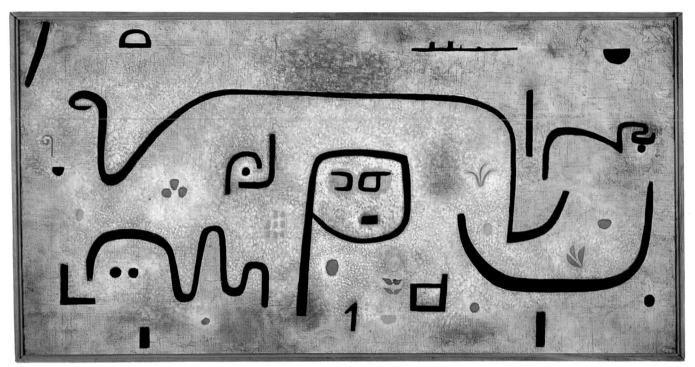

103

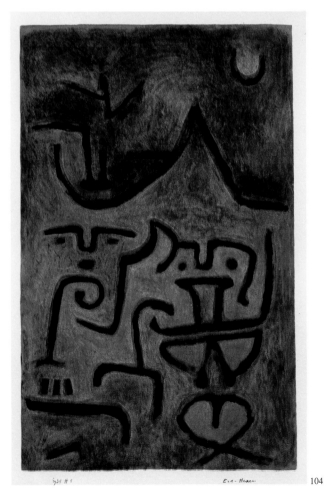

104

103. *Insula Dulcamara*. 1938.
 (Insula Dulcamara)
 Oil on newspaper mounted on burlap,
 34⅝ × 69¼ in. (88 × 176 cm).
 Klee Foundation, Kunstmuseum, Bern.

104. *Earth Witches*. 1938.
 (Erd-Hexen)
 Watercolor and varnished oil on paper mounted on cardboard,
 19 × 12¼ in. (48.5 × 31.2 cm).
 Klee Foundation, Kunstmuseum, Bern.

105. *Park near Lu[cerne]*. 1938.
 (Park bei Lu[zern])
 Oil on newspaper mounted on burlap,
 39⅜ × 27½ in. (100 × 70 cm).
 Klee Foundation, Kunstmuseum, Bern.

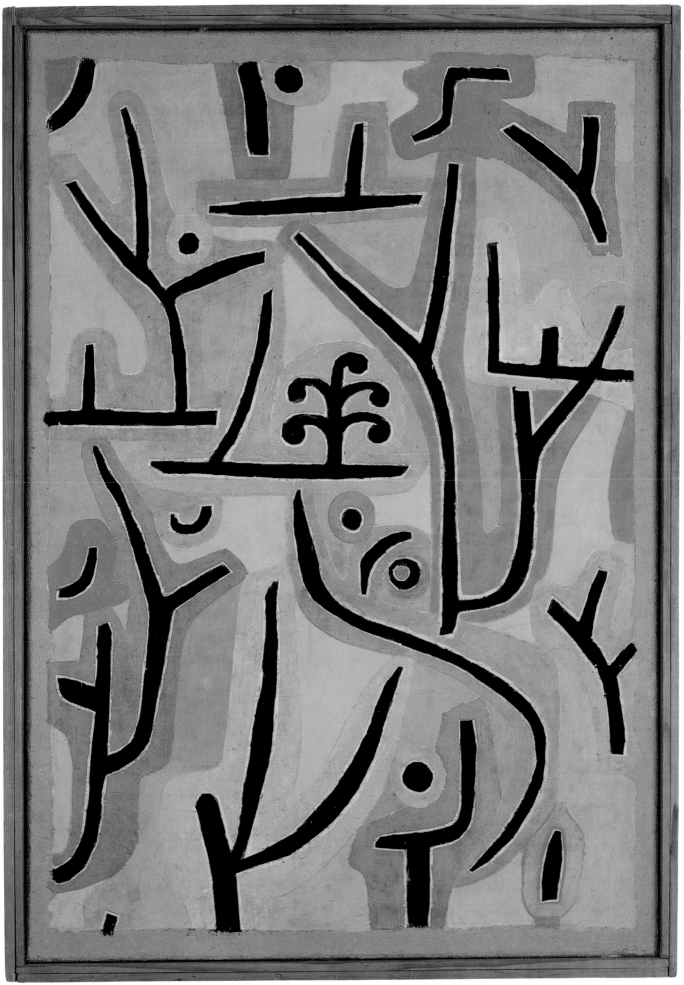

106. *Mr. H. Mel.* 1938.
 (Herr H. Mel)
 Watercolor and oil on plastered burlap mounted on cardboard,
 12⅛ × 20¾ in. (30.8 × 52.6 cm).
 Klee Foundation, Kunstmuseum, Bern.

107. *Pomona Overripe (Slightly Inclined).* 1938.
 (Pomona, überreif - leicht geneigt)
 Oil on newspaper mounted on cardboard,
 26¾ × 20½ in. (68 × 52 cm).
 Klee Foundation, Kunstmuseum, Bern.

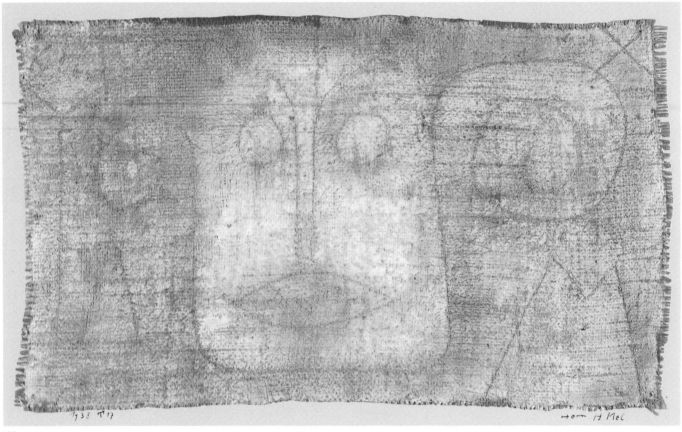

106

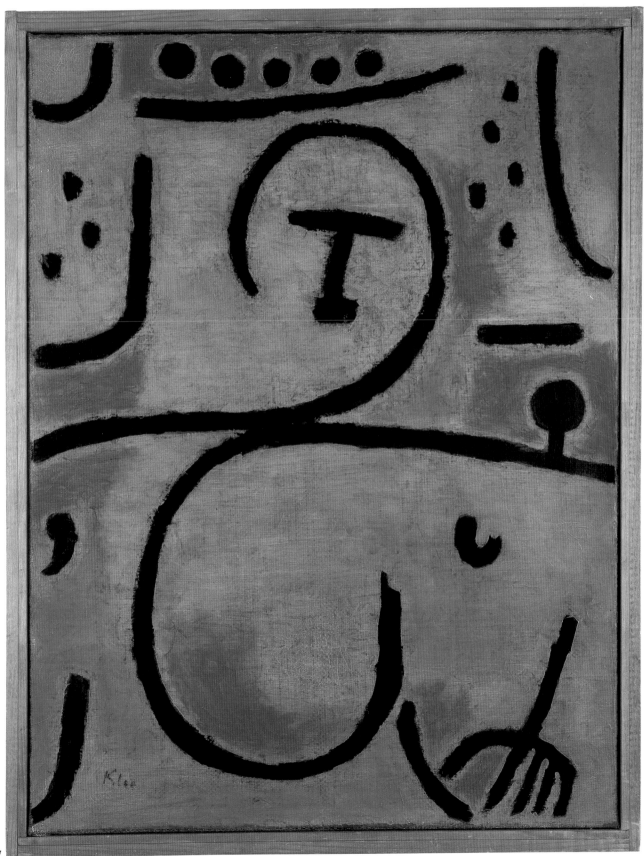

108. *Red-Eye*. 1939.
 (Rot-Aug)
 Colored paste and watercolor on paper mounted on cardboard,
 10½ × 16½ in. (26.8 × 42.1 cm).
 Klee Foundation, Kunstmuseum, Bern.

109. *La Belle Jardinière (a Biedermeier Ghost)*. 1939.
 (La belle jardinière - Ein Biedermeiergespenst)
 Oil and tempera on burlap,
 37⅜ × 27½ in. (95 × 70 cm).
 Klee Foundation, Kunstmuseum, Bern.

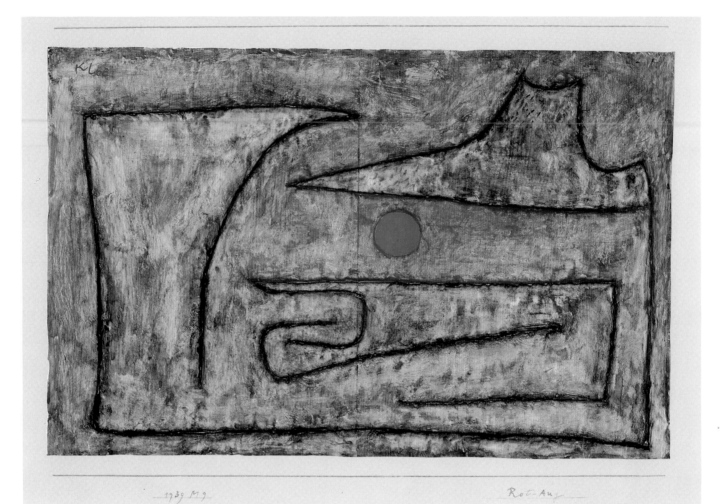

108

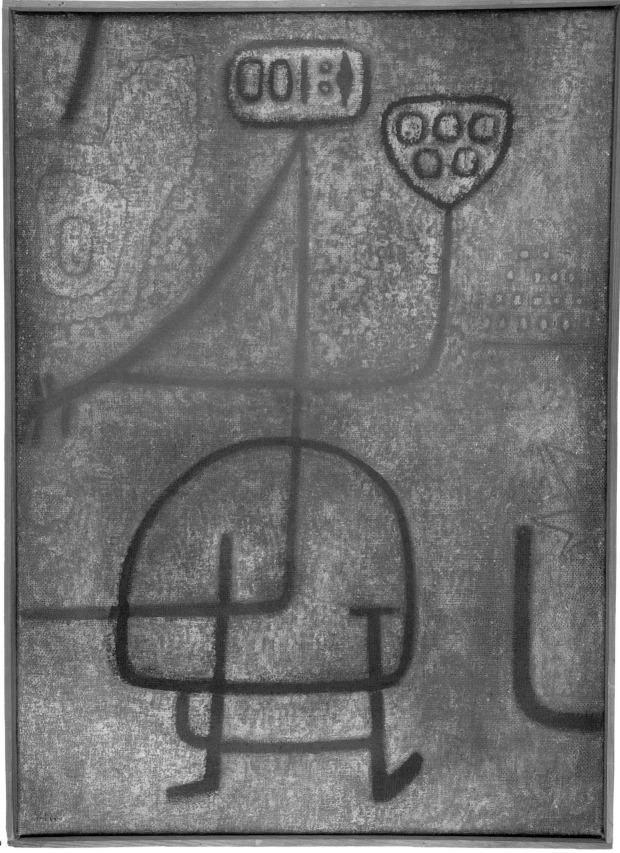

109

110. *Nymph in a Vegetable Garden*. 1939.
 (Nymphe im Gemüsegarten)
 Watercolor, gouache and black lithographic pencil on plastered burlap
 mounted on cardboard,
 13⅜ × 20⅝ in. (34 × 52.5 cm).
 Klee Foundation, Kunstmuseum, Bern.

111. *Group of Eleven*. 1939.
 (Gruppe zu elf)
 Colored paste and oil on paper mounted on cardboard,
 23⅞ × 17½ in. (60.5 × 44.4 cm).
 Klee Foundation, Kunstmuseum, Bern.

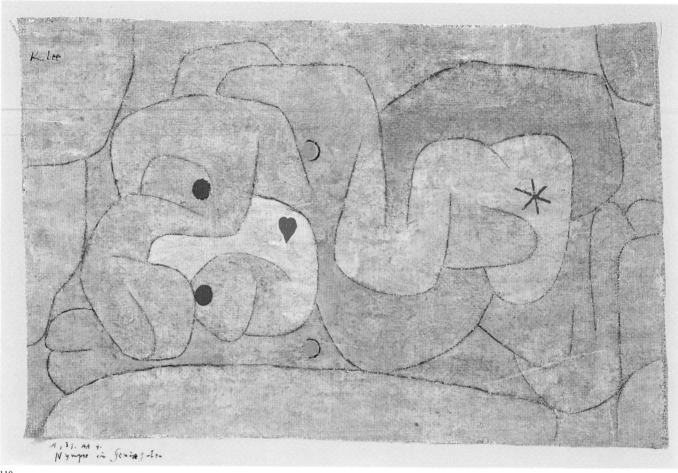

110

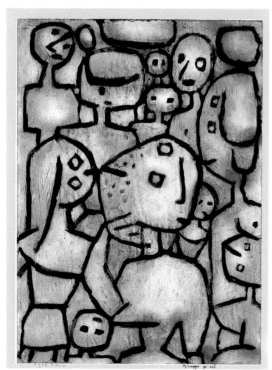

111

112. *Sleeping Quarters of the Four.* 1939
(Schlafstelle der Vier)
Oil and watercolor on paper mounted on cardboard,
12³/₈ × 18⁷/₈ in. (31.5 × 48 cm).
Klee Foundation, Kunstmuseum, Bern.

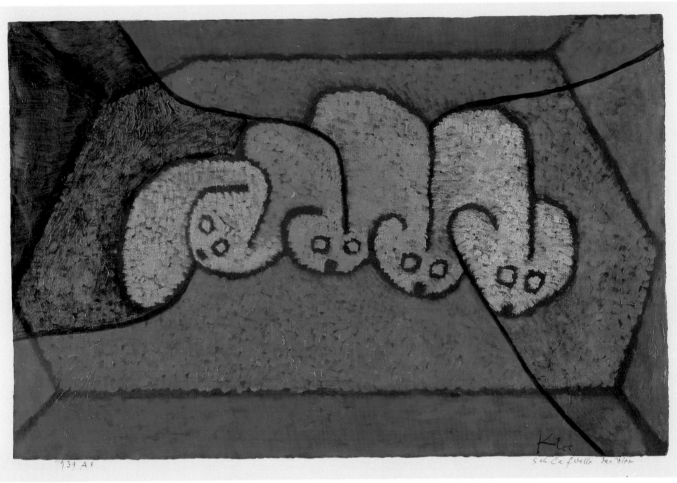

112

113. *Churches.* 1940.
(Kirchen)
Colored paste on paper mounted on cardboard,
12⅜ × 20½ in. (31.4 × 52.1 cm).
Klee Foundation, Kunstmuseum, Bern.

114. *Glass Façade.* 1940.
(Glas-Fassade)
Encaustic on burlap,
28 × 37⅜ in. (71 × 95 cm).
Klee Foundation, Kunstmuseum, Bern.

115. *Untitled.* Around 1940.
(Ohne Titel)
Black paste on paper mounted on cardboard,
11½ × 11⅞ in. (29.4 × 30.1 cm).
Klee Foundation, Kunstmuseum, Bern.

116. *Death and Fire.* 1940.
(Tod und Feuer)
Oil and colored paste on burlap,
18⅛ × 17⅜ in. (46 × 44 cm).
Klee Foundation, Kunstmuseum, Bern.

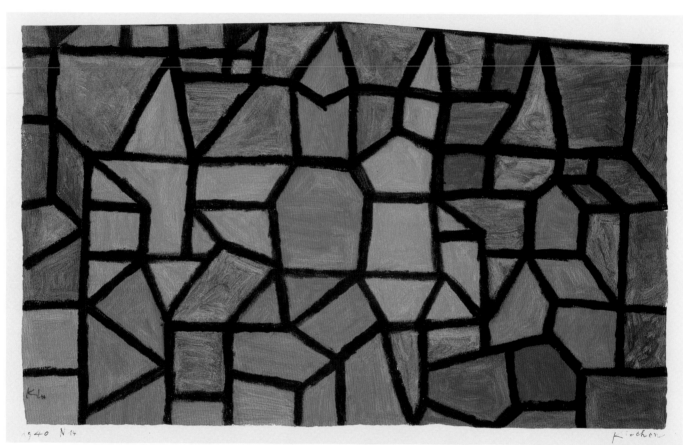

113

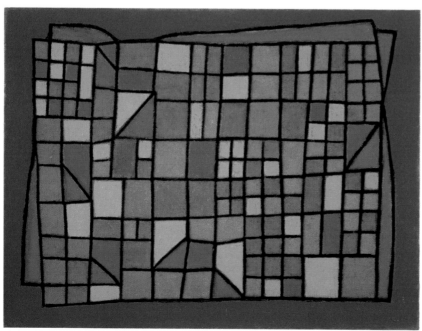

114

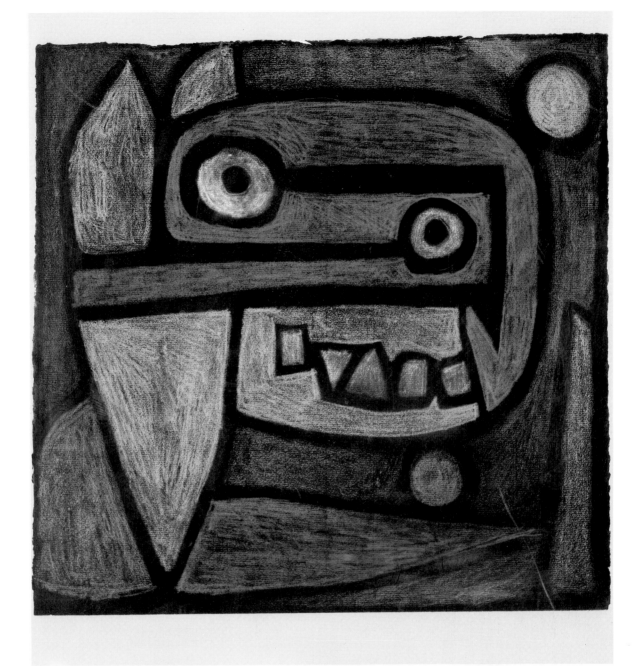

115

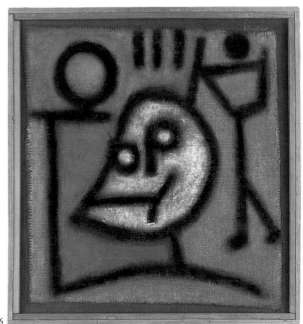

116

List of illustrations

1. *The Artist's Sister.* 1903.
(Die Schwester des Künstlers)
Oil and watercolor on cardboard,
10³/₄ × 12¹/₂ in. (27.5 × 31.5 cm).
Klee Foundation, Kunstmuseum, Bern.

2. *Portrait of My Father.* 1906.
(Bildnis meines Vaters)
India ink on glass (painted on the back),
12 × 11¹/₂ in. (32 × 29 cm).
Felix Klee Collection, Bern.

3. *Merman as Fetishist.* 1907.
(Der Wassermann als Fetischist)
Paint and watercolor on glass (painted on the back),
5 × 7 in. (12.9 × 17.7 cm).
Klee Foundation, Kunstmuseum, Bern.

4. *Virgin in a Tree.* 1903
(Jungfrau im Baum)
Etching,
9¹/₄ × 11³/₄ in. (23.6 × 29.6 cm).
Klee Foundation, Kunstmuseum, Bern.

5. *Gentleman and Lady in a Loge.* 1908.
(Herr und Dame in der Loge)
Black paint and watercolor on glass (painted on the back),
5 × 7 in. (12.9 × 17.8 cm).
Klee Foundation, Kunstmuseum, Bern.

6. *In the Quarry at Ostermundigen, Two Cranes.* 1907.
(Im Ostermundigen Steinbruch, zwei Kräne)
Charcoal, India ink and watercolor on paper mounted on cardboard,
24³/₄ × 19¹/₈ in. (63.1 × 48.6 cm).
Klee Foundation, Kunstmuseum, Bern.

7. *In the Quarry.* 1913.
(Im Steinbruch)
Watercolor on paper mounted on cardboard,
8³/₄ × 13⁷/₈ in. (22.3 × 35.2 cm).
Klee Foundation, Kunstmuseum, Bern.

8. *Female Nude (to the Knees).* 1910
(Weiblicher Akt - bis zu den Knien)
Oil on muslin mounted on cardboard,
15³/₈ × 9⁷/₈ in. (38.9 × 25 cm).
Klee Foundation, Kunstmuseum, Bern.

9. *Houses near the Gravel Pit (Sketched from Nature).* 1913.
(Häuser an der Kiesgrube - Naturskizze)
Watercolor on paper mounted on cardboard,
6¹/₈ × 6¹/₂ in. (15.6 × 16.7 cm).
Klee Foundation, Kunstmuseum, Bern.

10. *Saint-Germain, near Tunis.* 1914.
(Saint-Germain, près de Tunis)
Watercolor on paper mounted on cardboard,
8¹/₂ × 12³/₄ in. (21.6 × 32.4 cm).
Musée National d'Art Moderne, Paris.

11. *Before the Gates of Kairouan.* 1914.
(Vor den Toren von Kairouan)
Watercolor on paper mounted on cardboard,
8¹/₈ × 12³/₈ in. (20.7 × 31.5 cm).
Klee Foundation, Kunstmuseum, Bern.

12. *Motif from Hammamet.* 1914.
(Motiv aus Hammamet)
Watercolor on paper mounted on cardboard,
8 × 6¹/₈ in. (20.2 × 15.7 cm).
Öffentliche Kunstsammlung Basel,
Kunstmuseum.

13. *Quarry at Ostermundigen.* 1915.
(Steinbruch Ostermundigen)
Watercolor on paper mounted on cardboard,
8 × 9⁵/₈ in. (20.2 × 24.6 cm).
Klee Foundation, Kunstmuseum, Bern.

14. *Once Emerged from the Gray of Night...* 1918.
(Einst dem Grau der Nacht enttaucht...)
Watercolor on paper mounted on cardboard,
8⁷/₈ × 6¹/₈ in. (22.6 × 15.8 cm).
Klee Foundation, Kunstmuseum, Bern.

15. *Irma Rossa, the Animal Tamer.* 1918.
(Irma Rossa die Bändigerin)
Watercolor and India ink on paper mounted on cardboard,
11⁵/₈ × 9 in. (29.5 × 23 cm).
Sprengel Museum, Hannover.

16. *Statuette.* 1916.
(Statuette)
Gypsum, wood and watercolor,
14¹/₈ × 2¹/₂ × 3¹/₈ in. (36 × 6.5 × 8 cm).
Klee Foundation, Kunstmuseum, Bern.

17. *Statuette.* 1919.
(Statuette)
Polished tile, gypsum, wood, watercolor and India ink,
6⁷/₈ × 2³/₄ × 2³/₄ in. (17.5 × 7 × 7 cm).
Klee Foundation, Kunstmuseum, Bern.

18. *Statuette.* 1919.
(Statuette)
Polished tile, gypsum, wood, watercolor and India ink,
12 × 5³/₈ × 2¹/₂ in. (30.5 × 13.5 × 6.5 cm).
Klee Foundation, Kunstmuseum, Bern.

19. *Architecture with a Window.* 1919.
(Architektur mit dem Fenster)
Oil and India ink on paper mounted on board,
19³/₈ × 16³/₈ in. (50 × 41.5 cm).
Klee Foundation, Kunstmuseum, Bern.

20. *City Architecture with Green Church Tower.* 1919.
(Städtebau mit grünem Kirchturm)
Watercolor and gouache on paper mounted on cardboard,
12 × 5¹/₈ in. (30.3 × 13 cm).
Klee Foundation, Kunstmuseum, Bern.

21. *Station L 112, 14 km.* 1920
(Station L 112, 14 km.)
Watercolor and India ink on paper mounted on cardboard,
4⁷/₈ × 8¹/₂ in. (12.3 × 21.8 cm).
Kunstmuseum, Bern. Hermann and Margrit Rupf Foundation.

22. *An Angel Serves a Small Breakfast.* 1920.
(Ein Genius serviert ein kleines Frühstück)
Lithograph,
7³/₄ × 5³/₄ in. (19.8 × 14.6 cm).
Sprengel Museum, Hannover.

23. *Plan for a Garden Architecture.* 1920.
(Plan einer Gartenarchitektur)
Watercolor and oil on canvas mounted on cardboard,
14³/₈ × 16⁷/₈ in. (36.5 × 42.9 cm).
Klee Foundation, Kunstmuseum, Bern.

24. *Islands of the Birds.* 1921.
(Vogel-Inseln)
Watercolor and oil on paper mounted on cardboard,
12¹/₈ × 18 in. (30.8 × 45.8 cm).
Klee Foundation, Kunstmuseum, Bern.

25. *Crystal Gradation.* 1921.
(Kristall-Stuffung)
Watercolor on paper mounted on cardboard,
9⁵/₈ × 12³/₈ in. (24.5 × 31.5 cm).
Kunstmuseum, Basel.

26. *Tale à la Hoffmann.* 1921.
(Märchen à la Hoffmann)
Watercolor on paper mounted on fine cardboard,
12¹/₄ × 9¹/₂ in. (31.1 × 24.1 cm).
The Metropolitan Museum of Art, New York.
The Berggruen Klee Collection.

27. *The Vessels of Aphrodite, or: Ceramic-Erotic-Religious.* 1921.
(Die Gefässe der Aphrodite, oder: Keramisch/erotisch/religiös)
Watercolor on paper mounted on cardboard,
18¹/₄ × 11⁷/₈ in. (46.3 × 30.1 cm).
Klee Foundation, Kunstmuseum, Bern.

28. *Room Perspective with Inhabitants.* 1921.
(Zimmerperspektive mit Einwohnern)
Watercolor and oil on paper mounted on cardboard,
19 × 12¹/₂ in. (48.5 × 31.7 cm).
Klee Foundation, Kunstmuseum, Bern.

29. *Garden Plan.* 1922.
(Garten-Plan)
Watercolor and India ink on paper mounted on cardboard,
10¹/₂ × 13¹/₈ in. (26.6 × 33.5 cm).
Klee Foundation, Kunstmuseum, Bern.

30. *Mural from the Temple of Longing.* 1922.
(Wandtafel für den Longingtempel)
Watercolor, printer's ink and plastered canvas mounted on fine cardboard,
10¹/₂ × 14³/₄ in. (26.7 × 37.5 cm).
The Metropolitan Museum of Art, New York.

31. *Stricken Place.* 1922.
(Betroffener Ort)
Watercolor, India ink and pencil on paper mounted on cardboard,
13 × 9 in. (32.8 × 23.1 cm).
Klee Foundation, Kunstmuseum, Bern.

32. *Genii (Figures from a Ballet).* 1922.
(Genien. Figuren aus einem Ballett)
Watercolor and pencil on paper mounted on cardboard,
10¹/₈ × 6⁷/₈ in. (25.7 × 17.4 cm).
Klee Foundation, Kunstmuseum, Bern.

33. *Unstable Equilibrium.* 1922.
(Schwankendes Gleichgewicht)
Watercolor and pencil on paper mounted on cardboard,
13¹/₂ × 7 in. (34.5 × 17.8 cm).
Klee Foundation, Kunstmuseum, Bern.

34. *Castle in the Air.* 1922.
(Luftschloss)
Oil and watercolor on plastered gauze mounted on cardboard,
24⁵/₈ × 16 in. (62.6 × 40.7 cm).
Kunstmuseum Bern. Hermann and Margrit Rupf Foundation.

35. *Analysis of Diverse Perversities.* 1922.
(Analyse verschiedener Perversitäten)
Watercolor and India ink on paper mounted on cardboard,
12¹/₄ × 9¹/₂ in. (31 × 24 cm).
Musée National d'Art Moderne, Paris.

36. *God of the Northern Forest.* 1922.
(Der Gott des nördlichen Waldes)
Oil and India ink on canvas mounted on cardboard,
21 × 16¹/₄ in. (53.5 × 41.4 cm).
Klee Foundation, Kunstmuseum, Bern.

37. *Vocal Fabric of the Singer Rosa Silber.* 1922.
(Das Vokaltuch der Kammersängerin Rosa Silber)
Watercolor and plaster on muslin, mounted on cardboard,
24¹/₂ × 20¹/₂ in. (62.3 × 52.1 cm).
Collection, The Museum of Modern Art, New York. Gift of Mr. and Mrs. Stanley Resor.

38. *Twittering Machine.* 1922.
(Zwitscher-Maschine)
Watercolor, pen and ink oil transfer drawing,
25¹/₈ × 19 in. (63.8 × 48.1 cm).
Collection The Museum of Modern Art, New York. Purchase.

39. *Ventriloquist and Crier in the Moor.*
1923.
(Bauchredner und Ausrufer im Ödland)
Watercolor and printer's ink on paper
mounted on fine cardboard
15¼ × 12 in. (38.7 × 27.9 cm).
The Metropolitan Museum of Art, New York.
The Berggruen Klee Collection.

40. *North Sea Picture (from Baltrum).* 1923.
(Nordseebild, aus Baltrum)
Watercolor on paper mounted on cardboard,
9¾ × 12⅜ in. (24.7 × 31.5 cm).
Klee Foundation, Kunstmuseum, Bern.

41. *Magic Theater.* 1923.
(Zaubertheater)
India ink and watercolor on paper mounted
on cardboard,
13¼ × 9 in. (33.6 × 22.8 cm).
Klee Foundation, Kunstmuseum, Bern.

42. *Strange Garden.* 1923.
(Seltsamer Garten)
Watercolor on plastered canvas mounted on
fine cardboard,
15¾ × 11⅜ in. (40 × 28.9 cm).
The Metropolitan Museum of Art, New York.
The Berggruen Klee Collection.

43. *17, Astray.* 1923.
(Siebzehn, irr.)
Watercolor and India ink on paper mounted
on cardboard,
8⅞ × 11¼ in. (22.5 × 28.5 cm).
Öffentliche Kunstsammlung Basel,
Kunstmuseum.

44. *The Tightrope Walker.* 1923.
(Der Seiltänzer)
Watercolor, oil, pencil and India ink on
paper mounted on cardboard,
19⅛ × 12⅝ in. (48.7 × 32.2 cm).
Klee Foundation, Kunstmuseum, Bern.

45. *Harmony of Rectangles in Red, Yellow,
Blue, White and Black.* 1923
(Harmonie aus Vierecken mit Rot, Gelb,
Blau, Weiss und Schwarz)
Oil on cardboard,
27½ × 20 in. (69.7 × 50.6 cm).
Klee Foundation, Kunstmuseum, Bern.

46. *Cosmic Flora.* 1923.
(Kosmische Flora)
Watercolor and chalk background on paper
mounted on cardboard,
10¾ × 14⅜ in. (27.2 × 36.6 cm).
Klee Foundation, Kunstmuseum, Bern.

47. *Still Life with Props.* 1924.
(Requisiten-Stilleben)
Oil on muslin mounted on cardboard,
19 × 18½ in. (48.5 × 47.1 cm).
Klee Foundation, Kunstmuseum, Bern.

48. *Near Taormina. Scirocco.* 1924.
(Bei Taormina. Scirocco)
Watercolor and India ink on paper mounted
on cardboard,
6 × 9¼ in. (15.1 × 23.5 cm).
Klee Foundation, Kunstmuseum, Bern.

49. *Carnival in the Mountains.* 1924.
(Karneval im Gebirge)
Watercolor on paper mounted on cardboard,
10⅜ × 13 in. (26.5 × 33.1 cm).
Klee Foundation, Kunstmuseum, Bern.

50. *Wall Picture.* 1924.
(Wandbild)
Watercolor on muslin and paper mounted
on cardboard,
10 × 21⅝ in. (25.4 × 55.1 cm).
Klee Foundation, Kunstmuseum, Bern.

51. *Actor's Mask.* 1924.
(Schauspielermaske)
Oil on canvas, mounted on board,
14½ × 13⅜ in. (36.7 × 33.8 cm).
Collection, The Museum of Modern Art,
New York. The Sidney and Harriet Janis
Collection.

52. *The Mask with the Little Flag.* 1925.
(Maske mit Fähnchen)
Watercolor on paper mounted on cardboard,
25½ × 19½ in. (65 × 49.5 cm).
Staatsgalerie, Munich.

53. *Florentine Villa District.* 1926.
(Florentinische Villen)
Oil on canvas,
19½ × 14¾ in. (49.5 × 36.5 cm).
Musée National d'Art Moderne, Paris.

54. *Bird Wandering Off.* 1926.
(Auswandernder Vogel)
Gouache on canvas paper mounted on fine
cardboard,
14¾ × 18⅝ in. (37.5 × 47.3 cm).
The Metropolitan Museum of Art, New York.
The Berggruen Klee Collection.

55. *Fish People.* 1927.
(Fisch-Leute)
Oil and tempera on plastered canvas and
cardboard mounted on board,
12⅝ × 21⅝ in. (32.1 × 55 cm).
Klee Foundation, Kunstmuseum, Bern.

56. *She is Sinking into the Grave!* 1926.
(Sie sinkt ins Grab!)
Watercolor and India ink on paper mounted
on cardboard,
19 × 13½ in. (48.5 × 34.4 cm).
Klee Foundation, Kunstmuseum, Bern.

57. *Portrait of an Acrobat.* 1927.
(Artistenbildnis)
Oil and collage on cardboard over wood
with painted plaster border,
24⅞ × 15¾ in. (63.2 × 40 cm).
Collection, The Museum of Modern Art,
New York. Mrs. Simon Guggenheim Fund.

58. *Sailing-Ships.* 1927.
(Segelschiffe)
Watercolor on paper mounted on cardboard,
9 × 11⅞ in. (22.8 × 30.2 cm).
Klee Foundation, Kunstmuseum, Bern.

59. *Variations (Progressive Motif).* 1927.
(Variationen-Progressives Motiv)
Oil and watercolor on canvas,
16 × 15½ in. (40.6 × 39.4 cm).
The Metropolitan Museum of Art, New York.
The Berggruen Klee Collection.

60. *She Bellows, We Play.* 1928.
(Sie brüllt, wir spielen)
Oil on canvas,
17⅛ × 22¼ in. (43.5 × 56.5 cm).
Klee Foundation, Kunstmuseum, Bern.

61. *Cat and Bird.* 1928.
(Katze und Vogel)
Oil and ink on gessoed canvas, mounted on
wood,
15 × 21 in. (38.1 × 53.2 cm).
Collection, The Museum of Modern Art,
New York. Sidney and Harriet Janis
Collection Fund and gift of Suzy Prudden
and Loan H. Meijer in memory of F. H.
Hirschland.

62. *Arrow in the Garden.* 1929.
(Pfeil in einem Garten)
Oil on canvas,
27½ × 19⅝ in. (70 × 50 cm).
Musée National d'Art Moderne, Paris.

63. *Highroad and Byroads.* 1929.
(Hauptweg und Nebenwege)
Oil on canvas,
33 × 26½ in. (83.7 × 67.5 cm).
Museum Ludwig, Cologne.

64. *Dispute.* 1929.
(Disput)
Oil on canvas,
26⅜ × 26⅜ in. (67 × 67 cm).
Klee Foundation, Kunstmuseum, Bern.

65. *Monument in Fertile Country.* 1929.
(Monument im Fruchtland)
Watercolor on paper mounted on cardboard,
18 × 12⅛ in. (45.7 × 30.8 cm).
Klee Foundation, Kunstmuseum, Bern.

66. *Fire in Evening.* 1929.
(Feuer Abends)
Oil on cardboard,
13⅜ × 13¼ in. (33.8 × 33.4 cm).
Collection, The Museum of Modern Art,
New York. Mr. and Mrs. Joachim Jean
Aberbach Fund.

67. *Color Table (on Major Grey).* 1930.
(Farbtafel - auf maiorem Grau)
Pastel on cardboard,
14⅞ × 12 in. (37.7 × 30.4 cm).
Klee Foundation, Kunstmuseum, Bern.

68. *Polyphonically Enclosed White.* 1930.
(Polyphongafasstes Weiss)
Watercolor and India ink on paper mounted
on cardboard,
13⅛ × 9⅝ in. (33.3 × 24.5 cm).
Klee Foundation, Kunstmuseum, Bern.

69. *Open Book.* 1930.
(Aufgeschlagenes Buch)
Gouache and white lacquer on canvas,
17½ × 16⅜ in. (44.7 × 41.5 cm).
The Solomon R. Guggenheim Museum,
New York.

70. *Pyramid.* 1930.
(Pyramide)
Watercolor and India ink on paper mounted
on cardboard,
12¼ × 9⅛ in. (31.2 × 23.2 cm).
Klee Foundation, Kunstmuseum, Bern.

71. *Phantoms' Oath.* 1930.
(Gespenster-Schwur)
Watercolor and red chalk on paper mounted
on cardboard,
18½ × 14⅞ in. (47.1 × 37.8 cm).
Klee Foundation, Kunstmuseum, Bern.

72. *Ad Marginem.* 1930.
(Ad Marginem)
Watercolor and India ink on plastered gauze
mounted on cardboard,
17⅛ × 13 in. (43.5 × 33 cm).
Öffentliche Kunstsammlung Basel,
Kunstmuseum.

73. *Ad Parnassum.* 1932.
(Ad Parnassum)
Oil on canvas,
39⅜ × 49½ in. (100 × 126 cm).
Klee Foundation, Kunstmuseum, Bern.

74. *Castle Garden.* 1931.
(Schlossgarten)
Oil on canvas,
26½ × 21⅝ in. (67.2 × 54.9 cm).
Collection, The Museum of Modern Art,
New York. Sidney and Harriet Janis
Collection Fund.

75. *Mask of Fear.* 1932.
(Maske Furcht)
Oil on burlap,
39½ × 22½ in. (100.4 × 57.1 cm).
Collection, The Museum of Modern Art,
New York. Nelson A. Rockefeller Fund.

76. *North Room.* 1932.
(Nordzimmer)
Watercolor on paper mounted on cardboard,
14½ × 21⅝ in. (37 × 55 cm).
Klee Foundation, Kunstmuseum, Bern.

77. *Polyphony*. 1932.
(Polyphonie)
Oil on canvas,
41¾ × 26⅛ in. (106 × 66.5 cm).
Emanuel Hoffmann Foundation,
Kunstmuseum Basel.

78. *Small Town among the Rocks*. 1932.
(Kleine Felsenstadt)
Oil on canvas,
17½ × 22¼ in. (44.5 × 56.5 cm).
Klee Foundation, Kunstmuseum, Bern.

79. *Twilight in the Park*. 1932.
(Dämmerung im Park)
Watercolor and black drawing on plastered
canvas mounted on cardboard,
13½ × 24⅜ in. (34.4 × 62 cm).
Klee Foundation, Kunstmuseum, Bern.

80. *Sphinx Resting*. 1934.
(Ruhende Sphinx)
Oil on canvas,
35½ × 47¼ in. (90 × 120 cm).
Klee Foundation, Kunstmuseum, Bern.

81. *Seasnail King*. 1933.
(Meerschnecken-König)
Oil on canvas,
71½ × 22¼ in. (44.5 × 56.5 cm).
Klee Foundation, Kunstmuseum, Bern.

82. *The Creator*. 1934.
(Der Schöpfer)
Oil on canvas,
16½ × 21 in. (42 × 53.5 cm).
Klee Foundation, Kunstmuseum, Bern.

83. *Blossoming*. 1934.
(Blühendes)
Oil on canvas,
31⅞ × 31½ in. (81 × 80 cm).
Kunstmuseum, Winterthur.

84. *Dame Demon*. 1935.
(Dame Dämon)
Oil and watercolor on plastered burlap
mounted on cardboard,
59¼ × 39⅜ in. (150.5 × 100 cm).
Klee Foundation, Kunstmuseum, Bern.

85. *Planting According to Rules*. 1935.
(Nach Regeln zu Pflanzen)
Watercolor on paper mounted on cardboard,
10⅛ × 14½ in. (25.8 × 36.9 cm).
Kunstmuseum, Bern. Hermann and Margrit
Rupf Foundation.

86. *Light and Sharp Edges*. 1935.
(Das Licht und die Schärfen)
Watercolor on paper mounted on cardboard,
12½ × 18⅞ in. (32 × 48 cm).
Klee Foundation, Kunstmuseum, Bern.

87. *Flower Garden in the Park of V*. 1936.
(Blumenanlage im Park von V.)
Pastel on cotton cloth mounted on
cardboard,
20 × 18⅜ in. (30.3 × 46.6 cm).
Klee Foundation, Kunstmuseum, Bern.

88. *New Harmony*. 1936.
(Neue Harmonie)
Oil on canvas,
37 × 26 in. (94 × 66 cm).
The Solomon R. Guggenheim Museum,
New York.

89. *Harbor with Sailboats*. 1937.
(Hafen und Segelboote)
Oil on canvas,
31½ × 23⅝ in. (80 × 60 cm).
Musée National d'Art Moderne, Paris.

90. *Blue Night*. 1937.
(Blaue Nacht)
Gouache on cotton cloth mounted on
burlap,
19¾ × 30 in. (50.3 × 76.4 cm).
Öffentliche Kunstsammlung, Basel.

91. *Legend of the Nile*. 1937.
(Legende vom Nil)
Pastel on cotton cloth mounted on burlap,
27⅛ × 24 in. (69 × 61 cm).
Kunstmuseum, Bern. Hermann and Margrit
Rupf Foundation.

92. *Harmonized Battle*. 1937.
(Harmonisierter Kampf)
Pastel on cotton cloth mounted on burlap,
22½ × 33⅞ in. (57 × 86 cm).
Klee Foundation, Kunstmuseum, Bern.

93. *Stage Landscape*. 1937.
(Bühnen-Landschaft)
Pastel on cotton cloth mounted on burlap,
23 × 33⅞ in. (58.5 × 86 cm).
Kunstmuseum Berna. Hermann and Margrit
Rupf Foundation.

94. *Flora*. 1937.
(Flora)
Oil on paper mounted on cardboard,
15½ × 11⅜ in. (39.4 × 28.9 cm).
Klee Foundation, Kunstmuseum, Bern.

95. *A Glance Out of Egypt*. 1937.
(Ein Blick aus Aegypten)
Pastel on paper mounted on cardboard,
10⅞ × 6½ in. (27.6 × 16.3 cm).
Klee Foundation, Kunstmuseum, Bern.

96. *Aeolian*. 1938.
(Aeolisches)
Oil on newspaper mounted on burlap,
20½ × 26¾ in. (52 × 68 cm).
Kunstmuseum, Berna, Hermann and Margrit
Rupf Foundation.

97. *Heroic Strokes of the Bow*. 1938.
(Heroische Bogenstriche)
Colored paste on newspaper on dyed cotton
fabric,
28¾ × 20⅞ in. (73 × 52.7 cm).
Collection, The Museum of Modern Art,
New York. Nelson A. Rockefeller Bequest.

98. *Coelin Fruit*. 1938.
(Coelin-Frucht)
Colored paste on paper mounted on
cardboard,
14 × 10½ in. (35.4 × 26.6 cm).
Klee Foundation, Kunstmuseum, Bern.

99. *Three Young Exotics*. 1938.
(Drei junge Exoten)
Colored paste on paper mounted on
cardboard,
18⅜ × 15⅝ in. (46.6 × 39.8 cm).
Klee Foundation, Kunstmuseum, Bern.

100. *Early Sorrow*. 1938.
(Frühes Leid)
Oil and watercolor on plastered burlap
mounted on cardboard,
13⅝ × 17¾ in. (34.4 × 45 cm).
Klee Foundation, Kunstmuseum, Bern.

101. *Rich Harbor*. 1938.
(Reicher Hafen)
Tempera on paper mounted on canvas,
29¾ × 65 in. (75.5 × 165 cm).
Öffentliche Kunstsammlung Basel,
Kunstmuseum.

102. *Intention*. 1938.
(Vorhaben)
Colored paste on newspaper mounted
on burlap,
29½ × 44 in. (75 × 112 cm).
Klee Foundation, Kunstmuseum, Bern.

103. *Insula Dulcamara*. 1938.
(Insula Dulcamara)
Oil on newspaper mounted on burlap,
34⅝ × 69¼ in. (88 × 176 cm).
Klee Foundation, Kunstmuseum, Bern.

104. *Earth Witches*. 1938.
(Erd-Hexen)
Watercolor and varnished oil on paper
mounted on cardboard,
19 × 12¼ in. (48.5 × 31.2 cm).
Klee Foundation, Kunstmuseum, Bern.

105. *Park near Lu[cerne]*. 1938.
(Park bei Lu[zern])
Oil on newspaper mounted on burlap,
39⅜ × 27½ in. (100 × 70 cm).
Klee Foundation, Kunstmuseum, Bern.

106. *Mr. H. Mel*. 1938.
(Herr H. Mel)
Watercolor and oil on plastered burlap
mounted on cardboard,
12⅛ × 20¾ in. (30.8 × 52.6 cm).
Klee Foundation, Kunstmuseum, Bern.

107. *Pomona Overripe (Slightly Inclined)*.
1938.
(Pomona, überreif - leicht geneigt)
Oil on newspaper mounted on cardboard,
26¾ × 20½ in. (68 × 52 cm).
Klee Foundation, Kunstmuseum, Bern.

108. *Red-Eye*. 1939.
(Rot-Aug)
Colored paste and watercolor on paper
mounted on cardboard,
10½ × 16½ in. (26.8 × 42.1 cm).
Klee Foundation, Kunstmuseum, Bern.

109. *La Belle Jardinière (a Biedermeier
Ghost)*. 1939.
(La belle jardinière - Ein
Biedermeiergespenst)
Oil and tempera on burlap,
37⅜ × 27½ in. (95 × 70 cm).
Klee Foundation, Kunstmuseum, Bern.

110. *Nymph in a Vegetable Garden*. 1939.
(Nymphe im Gemüsegarten)
Watercolor, gouache and black lithographic
pencil on plastered burlap mounted on
cardboard,
13⅜ × 20⅝ in. (34 × 52.5 cm).
Klee Foundation, Kunstmuseum, Bern.

111. *Group of Eleven*. 1939.
(Gruppe zu elf)
Colored paste and oil on paper mounted on
cardboard,
23⅞ × 17½ in. (60.5 × 44.4 cm).
Klee Foundation, Kunstmuseum, Bern.

112. *Sleeping Quarters of the Four*. 1939
(Schlafstelle der Vier)
Oil and watercolor on paper mounted on
cardboard,
12⅜ × 18⅞ in. (31.5 × 48 cm).
Klee Foundation, Kunstmuseum, Bern.

113. *Churches*. 1940.
(Kirchen)
Colored paste on paper mounted on
cardboard,
12⅜ × 20½ in. (31.4 × 52.1 cm).
Klee Foundation, Kunstmuseum, Bern.

114. *Glass Façade*. 1940.
(Glas-Fassade)
Encaustic on burlap,
28 × 37⅜ in. (71 × 95 cm).
Klee Foundation, Kunstmuseum, Bern.

115. *Untitled*. Around 1940.
(Ohne Titel)
Black paste color on paper mounted on
cardboard,
11½ × 11⅞ in. (29.4 × 30.1 cm).
Klee Foundation, Kunstmuseum, Bern.

116. *Death and Fire*. 1940.
(Tod und Feuer)
Oil and paste colors on burlap,
18⅛ × 17⅜ in. (46 × 44 cm).
Klee Foundation, Kunstmuseum, Bern.